Giorgio Morandi

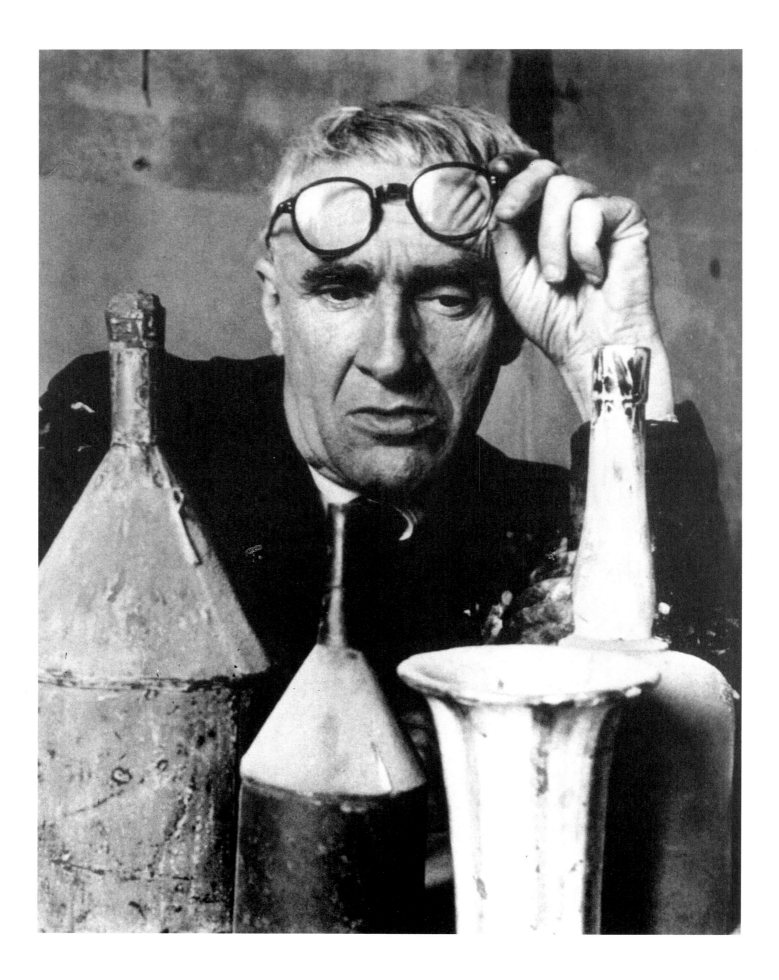

Giorgio Morandi

Paintings
Watercolours
Drawings
Etchings

Edited by
Ernst-Gerhard Güse
and Franz Armin Morat

With contributions by
Gottfried Boehm, Ernst-Gerhard Güse,
Wolfgang Holler and Franz Armin Morat

Prestel

Munich · London · New York

Front cover: *Still Life*, 1962 (plate 22)
Back cover: *Still Life*, 1957 (plate 14)
Endpapers, front and back: In Giorgio Morandi's studio
Frontispiece: Giorgio Morandi, 1953

Translated from the German by Almuth Seebohm, Munich
Copyedited by Christopher Wynne

Library of Congress Cataloguing-in-Publication Data is available

© Prestel Verlag, Munich · London · New York, 1999
© of works illustrated by Giorgio Morandi, by VG Bild-Kunst, Bonn, 1999

Photographic Credits: see page 168

PRESTEL VERLAG
Mandlstrasse 26 · 80802 Munich
Tel. (089) 38 1709-0, Fax (089) 38 1709-35;
16 West 22nd Street · New York, NY 10010
Tel. (212) 627-8199, Fax (212) 627-9866;
4 Bloomsbury Place · London WC1A 2QA
Tel. (0171) 323 5004, Fax (0171) 636 8004

Prestel books are available worldwide.
Please contact your nearest bookseller
or one of the above Presel offices for
details concerning your local distributor.

Lithography by Brend'amour, Munich,
Rete-Repro, Freiburg,
Repro Brüll, Saalfelden
Typeset by Max Vornehm, Munich
Font type: Monotype Walbaum
Printed by Pera-Druck, Munich
Bound by Almesberger, Salzburg

Printed in Germany on acid-free paper

ISBN 3-7913-2086-6

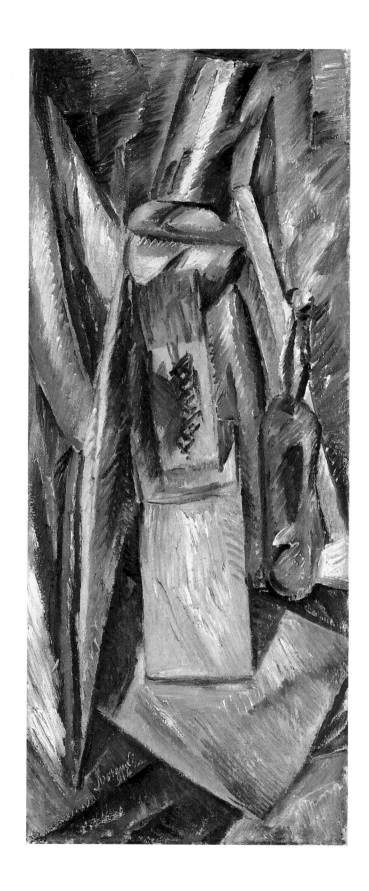

Still Life, 1914

Foreword

"He lived and worked in a medium-sized sitting room. Its one window faced a small courtyard with trees, which we know from several pictures of his and which he painted surrepticiously, as it were, under cover of this window. Here was his narrow camp bed, an old-fashioned combined desk and drawing table, a kind of bookcase, his easel. And all around, on narrow shelves, was the silent, patiently waiting arsenal of everyday objects, all of which we know from his still lifes: bottles, vessels, vases, pitchers, kitchen utensils, tins." That is how Werner Haftmann described Giorgio Morandi's flat in Via Fondazza in Bologna, where he lived with his three sisters and where, painting with concentration and quiet intensity, he studied the things of everyday life. A few objects sufficed for him to create his own poetic world in the still lifes of his paintings, watercolours, drawings and etchings. He seldom left Bologna, his native city. He never visited Paris, the centre of attraction for artists from all over Europe in the first half of the century. Nevertheless, his art — embedded in the traditions of Italian painting — gained international recognition. Morandi is one of the most highly esteemed outsiders among 20th-century artists. Critics have sometimes called him an eccentric, a monk or a saint, who refused any attempt at being put into service by art, and who created an oeuvre that precluded any metaphysical, religious, or political connections, or anything programmatic whatsoever. "Objective abstraction" is the name of the concept found to label Morandi's art, with its quality of remaining figurative while accenting formal elements. Artists Morandi admired were the Italian painters of the Renaissance, Giotto, Uccello, Masaccio and Piero della Francesca, as well as Chardin, whom he called "the greatest of all still life painters," and Corot, the master of stillness. He owned a drawing by Cézanne and one by Seurat — both artists providing inspiration for his own work.

As limited to a few motifs as Morandi's oeuvre may seem to the superficial viewer, it is rich to anyone who can let themselves be captured by the meditative stillness of these works. They demand quiet contemplation; they teach seeing. "Giorgio Morandi only painted bottles and jugs all his life," wrote the author Horst Bienek, and continued: "In these pictures he said more about life, about real life, than there is in all the colourful pictures around us."

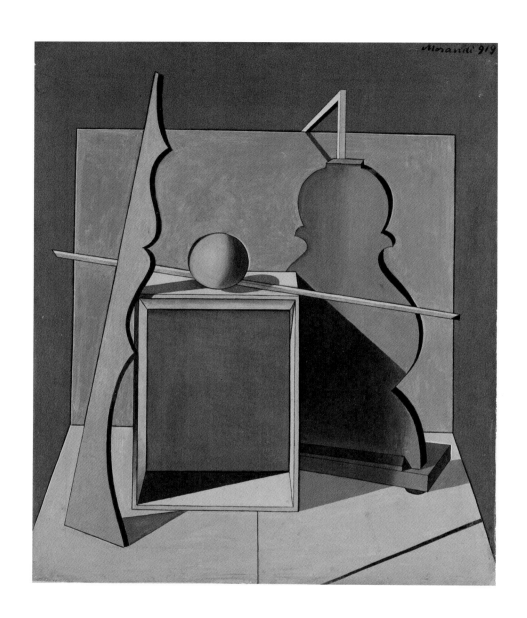

Still Life, 1919

Gottfried Boehm

Giorgio Morandi's Artistic Concept

I

As this century draws to a close, our views of its history are shifting. We still know surprisingly little about the driving historical forces behind the upheavals and revolutions that dramatically changed the face of art. Re-evaluations are in progress. They are apt to show us many an artist and many a work of art in a new light, bringing much to our awareness only just now. Morandi's oeuvre, too, is the object of a more profound process of assimilation that not only sanctions his 'classical' status but also creates opportunities for new approaches. Hence this volume may well be appearing at the right time. First and foremost, it presents a collection of works which is unequaled outside the Morandi Museum, and which concentrated on Morandi at a time when he was still overshadowed by widespread indifference.[1] The collection's focal points create emphases capable of reshaping the image of the artist. They make the significance of Morandi's late works, his astonishing drawing technique and his revival of watercolour stand out more clearly. Our thoughts on the concept of this artist take this especially into account, though without ignoring other points of view.

Morandi's involvement in 20th-century art history is for the most part well known: his life-long preoccupation with Cézanne (figs 1 and 2), his heritage of Italian tradition as summed up in the concept of 'Italianità,' his brief reception of Cubism (fig. 3), his share of 'Pittura metafisica' (fig. 4) and his membership in the circle around the magazine *Valori Plastici* – these names and key terms indicate the major connections.[2] As much as he may have moved in contemporary circles, however, for many viewers and critics he is a marginal figure of modern art history.

The historical and artistic assessment of Morandi has always depended upon the criteria used to define modernity. In the post-war period a model came into circulation that characterised the history of modern art as a process of increasing reduction. According to its stages, it was possible to gauge whether an artist was up-to-date. This idea possessed a certain plausibility: reduction is indeed fundamentally associated with modern art, and around 1950 abstraction had developed into a (supposedly) 'international language.' Striving towards increasing reduction can even be shown to be the hidden or professed ideology of many modern artists and critics up to the beginning of the eighties. Hasn't the post-war development of art obeyed this very logic? Trends and movements from 'Art informel,' 'abolishing the picture frame' and 'departing from the picture' to 'Minimal art' or 'Conceptual art' seemed to brilliantly confirm this historic necessity.[3] Abstraction eventually

1 The history of the reception of Morandi's art has not yet been written, particularly not that north of the Alps, in Germany and Switzerland. Some events are covered by Werner Haftmann, including the early presence of his work in Berlin (1921) at a joint exhibition at the Nationalgalerie entitled *Das junge Italien* (Young Italy), opened by Ludwig Justi and Theodor Däubler. – It is well known that Morandi took the only trip abroad of his life to Winterthur in 1956 to prepare an exhibition. See also: Werner Haftmann, 'Giorgio Morandi – Ein exemplarisches Malerleben', in: *Giorgio Morandi, 1890–1964. Gemälde, Aquarelle, Zeichnungen, Radierungen*, exhib. cat. Kunsthalle Tübingen, Kunstsammlung Nordrhein-Westfalen, Düsseldorf, Cologne 1989, pp. 10, 20.

2 A brief summary in German is provided by the chronology in the exhib. cat. Tübingen/Düsseldorf 1989 (as in note 1), pp. 275ff.

9

devoured its own children: the abstract picture, the abstract sculpture disappeared in the name of an art of conceptual immaterialism, or dematerialisation. In the end, artistic character was attributed solely to the invisible intellectual act.

In the light of these dynamics Morandi could not help appearing as a harmless conservative, an Italian regionalist with taste and painterly culture, who lacked a true contemporary feeling — one that would not balk at the paradoxes and contradictions of modern society.

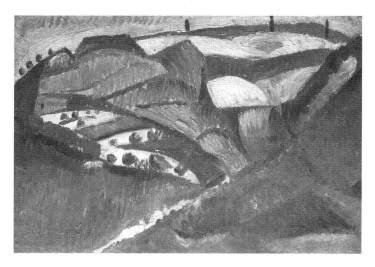 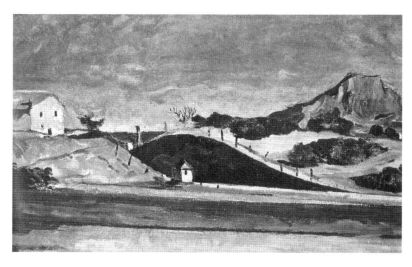

Fig. 1 *Landscape*, 1913. Oil on canvas, 40 × 50 cm (V.9). Bologna, private collection

Fig. 2 Paul Cézanne, *The Railway Pass*, ca. 1870. Oil on canvas, 80 × 138 cm. Munich, Neue Pinakothek

While Morandi's artistic concept was on the one hand being overtaken by the claims of the avant-garde, on the other it had to put up with an unconscious political criticism. This was formulated by leftist authors, who branded him a representative of a deplorable aestheticism, an unpolitical artist, worse still: a secret follower of Mussolini. Morandi as a strategist of autonomy, as a minor master of bourgeois introspection — such were the characteristics still cited in 1981 on the occasion of the first major German Morandi retrospective in Munich. The same findings, albeit under opposing political auspices, were voiced by some conservative authors, who found 20th-century art as a whole disgusting and a cause for the pessimistic calculation of deficits. They saw the detached serenity of Morandi as one of the few assets in the art history of our era.

Predictably, 'the history of reduction' model foundered on its fulfillment. When there was finally nothing left to reduce, anti-intellectual vitalism seemed to be the answer. A new wildness was called for and the gut was declared the programme. In the process, all of modern art acquired an odour of belonging to the past. Since then, historical circumstances have become somewhat clearer. With the decline of antimodernist or postmodernist ideologies, conditions for more objective evaluations of modernism and modern artists are improving. Morandi, too, can now be seen with different eyes; the debate can begin anew. What is his art about? How did he come to terms with reality? What form did he give it? What understanding and experience does the viewer gain from his art? In brief: what is Morandi's concept?

3 See also Gottfried Boehm, 'Bilder jenseits der Bilder. Transformationen in der Kunst des 20. Jahrhunderts', in: *Transform. BildObjeckt — Skulptur im 20. Jahrhundert*, exhib. cat. Basel 1992, pp. 15ff.

4 Alberto Giacometti, too, cited Cézanne in his experiments. He had discovered the abyss entailed by exact seeing and knew how to master it. See Giacometti's comments on Cézanne in conversation with Georges Charbonnier: Alberto Giacometti, *Was ich suche*, Zurich 1973, pp. 32ff.

A possible answer must be able to stand up to the visual data in his works. They make a self-contained impression, or rather, reserved. This results from the undistracted intensity of his creative work. Variety comes about not through the subject-matter but through how it is observed; the imagination in the choice of theme is completely ruled out. Within the framework of his two preferred genres, still life and landscape, the artist assigns

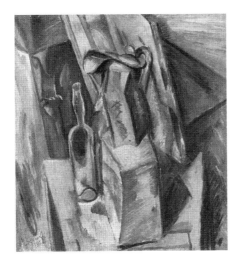 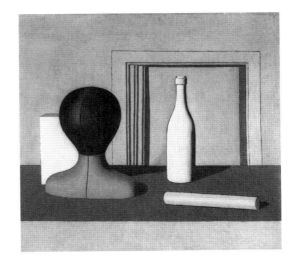

5 Similar to Cézanne's words: "After seeing the great masters deposited in the Louvre, we should hurry to leave again and try to bring ourselves back to life through contact with nature, with the instincts and the artistic sensitivity that is within us." Passed on by A. Vollard, *Paul Cézanne*, Zurich 1960, p. 79.

6 This was pointed out repeatedly, above all by Ernst Strauss in conversation. See his essay on Morandi's colours: 'Bemerkungen zur Bildanlage, Licht und Farbe in den Stilleben Giorgio Morandis', in: Ernst Strauss, *Koloritgeschichtliche Untersuchungen zur Malerei seit Giotto und andere Studien*, Munich 1983, p. 241.

himself the given visible circumstances. While Morandi may have had contact with the fantastic world of Surrealism during his 'Pittura metafisica' period, his concept ever since the beginning of the twenties is based solely on a descriptive relationship to reality. A sort of key painting for this fresh start is the *Natura morta* of 1920 (plate 1). Incidentally, twenty years later (about 1940) another artist, who had ventured much farther into the pictorial world of the unconscious, took the same path himself. Alberto Giacometti, during a terrible crisis in his work at the time of the Second World War, sought and found access to a 'primary scene.' Morandi had acquired his own artistic troubles and strengths from it earlier: it concerns the eye, face to face with an object.[4] A brief comparison between the two artists suffices to disprove the widespread notion that the close observation of reality involves stilistic standards that could only result in realism. Faced with the same issue, they each worked completely differently. They each knew how to make productive, i.e. perceptive, use of their eyes.

When Morandi is called a 'bottle painter,' this disparaging label insinuates that the artist had an interest in the iconography of these vessels. In fact, the simple volumes of the tins, vases or bottles were representatives of a reality that only unveils its wealth, its essence, once the viewing eye observes what is characteristic of them: the profusion and the inexhaustibility in which they display themselves. We have thus outlined the first of the two authorities on which Morandi's artistic concept is oriented. Everything he painted is about visual experience.

Fig. 3 *Still Life*, 1914. Oil on canvas, 73 × 64.5 cm (V.13). Milan, Private collection

Fig. 4 *Still Life*, 1918. Oil on canvas, 68.5 × 72 cm (V.35). Milan, Pinacoteca di Brera

The second authority concerns his approach to history, particularly the history of art. He understood it as tradition, in which the binding orientations of the past were capable of being renewed over and over again.[5] Decisive for him is not the timid preservation of bygones (which could be characterised as traditionalism), but rather the ability to tap, under completely different historical circumstances, the power of the legacy. The insights and pictorial ideas of classical modern art (Cézanne, Seurat, Monet, etc., up to Corot) and earlier Italian art belong to this kind of tradition. Morandi's colour sense can be said to have an elective affinity to earlier Bolognese painting, formulating similar basic tones, stemming from the very artistic landscape he himself came from.[6] On the strength of the above, we can compare paintings such as those by Domenichino with his from the point of view of tonality. Carlo Carrà, Morandi's fellow combatant in art, was one of the rediscoverers of Piero della Francesca. Piero's adoption also left behind traces in Morandi's oeuvre. In fact, Italian art of the early Renaissance, e.g. by Giotto, Masaccio and Uccello, came to be seen with fresh eyes in the early twenties. From this fruitful legacy Morandi drew a decisive impetus.[7] While this cannot be proven stylistically, it shows in a related world view. It is characterised above all by an inclination towards calm, to a constancy in objects which cannot be affected by change. It is a Parmenidean reality into which Morandi's pictures transplant us. This timelessness bore a heightened, sometimes even demonic, presence during his 'Pittura metafisica' phase. Later, such an exaggerated resonance was abandoned in favour of an unemotional, sober gaze, entirely focused on reality. It encounters what Werner Haftmann called the "original solidity of visible objects" and which he identified, in turn, with the concept of 'Italianità.'[8] This is also apparent in the works by the old masters mentioned above. We would probably do well to define the term culturally, say, as the expression of Italian culture to be found in architecture and sculpture, as well as in the approach to nature, in the population's sense of time, etc.

The modern revolution has often been seen as a deliberate break with tradition. This view needs correcting. In fact, modern artists established a new and different view of the past. The historical self-perception of Malevich, Mondrian, Kandinsky, or Picasso is not defined by any attempt to place themselves outside of history. Rather, their intention was to develop concealed, buried or forgotten aspects, be it the rigidity of Byzantine Orthodox pictorial thought, the universal unity of the Nordic understanding of nature, or the paganism of the Mediterranean.[9] In this sense Morandi's 'Italianità' is also based on a modern artistic awareness. It is not about depicting the solidity of objects but rather interpreting them as a metaphor: of light, space, body and time.

III

It is no coincidence that both of his authorities recall Cézanne, who had made 'nature' and the 'Louvre' his rule. Despite their diverse historic rootage, Cézanne remains the key figure for Morandi. It has often been

7 Carlo Carrà had his book on Giotto published by the "Valori Plastici" publishing house in Rome in 1924. On pp. 7ff he wrote: "Giotto's work has great contemporary value for us ... Mainly because it is one of the most original creations of artistic genius of the Italian people, who were the most important avant-garde in the visual arts of western art as a whole. Furthermore, because in the so-called formal incompetency of Giotto we find a valuable lesson to be ruthlessly frank with ourselves in turn. And finally, because outstanding artists of the modern era exhibit a similar incompetency. Without naming a lot of names, let us restrict ourselves to the work of Paul Cézanne and Giovanni Fattori ..." Roberto Longhi had his essay on Piero della Francesca published by the same "Valori Plastici" publisher in 1927.

8 Haftmann 1989 (as in note 1), pp. 10, 13.

9 The Blue Rider almanac could be interpreted as an example documenting the historic self-perception of the avant-garde artists assembled in it. As we know, a completely different historical order developed on this occasion. According to this, Gothic art, folk art, the art of non-European tribes and civilisations, etc. had the same rank as the art of classical antiquity, Renaissance humanism, etc. in the traditional scheme.

attempted to trace how the reluctant traveller came into contact with Cézanne's pictures. Whatever the respective roles of reproductions or original works may have been, Morandi only found himself as an artist once he had seen Cézanne's art and had advanced Cézanne's thought in a productive manner. He belongs to a host of modern painters to whom this father figure showed the way. Extremely different sons were among them: Malevich, Matisse, Picasso, Braque and Mondrian. What they all have in common is that they did not seek to imitate him stylistically but had recognized that his importance lay in something more fundamental. The signs that could be read in his art pointed in various different directions. The standard Cézanne represented was gauged by the productive consequences it triggered, not by a superficial rightness.

Yet what is it that makes Cézanne's art so far-reaching and revelatory? Two factors are of special interest in this context: Cézanne's perception of nature and the altered pictorial concept it permitted formulating. His famous phrase, "... I don't do anything I don't see, and whatever I paint exists," could have been used by Morandi too.[10] Yet what does the 'seeing' that almost all artists since Giotto have cited mean in this case? Cézanne's groundbreaking insight had to do with the fact that his scrutinizing gaze at nature (at objects, people, mountains, trees, etc.) raised doubt. Interpreting the world as foreign, as a puzzle or a labyrinth was of course nothing new. The Mannerists and the great fantastic artists of the 18th and 19th centuries (Piranesi, Goya, Delacroix, Blake, Moreau, etc.) had done so, sensing and formulating the imbalance between mankind and the world. Creating his own idea of reality, however, was certainly not Cézanne's aim. He sought solid foundations for his work. If they were to be found at all, they had to lie within the evidence from the observing eye, not in the dreams of the imagination. His stress on a methodical critical gaze had complex historical causes (incidentally also parallels). It is evident, for instance, in how the visible world presented itself to Cézanne in an abundance (which he referred to as "diversity"[11]) that in itself no longer represented an established order. Cézanne's remarks on the 'visual data' ("sensations") that should be painted mean nothing more than that: to paint data, i.e. the appearance of reality, does not mean to transfer a pre-existent and visible order onto the picture. Rather, painting has the function of exploring and developing that visible world by applying its own system of order. Doubt is inspired by the open and unfinished nature of the visible world, by its intrinsic foreignness.

Morandi, who had lent this foreignness an enigmatic expression in his 'Pittura metafisica' phase, had to have been fascinated by Cézanne's refutation of imagination, composition and invention.[12] He realised that the master of Aix had developed a process that made it possible to subject the slightest sense of inappropriateness to a control, and to get to the bottom of it through creative endeavour. It was less the 'harmonic background' of his art that recalls Cézanne's pictures, it was Cézanne's process of controlled seeing, providing as it did opportunities for later artists to make a connexion. When Morandi speaks of "cosiddetta realtà" (saying "so-called reality" when he means reality), he again reflects Cézannesque insight. The term refers to nature as not simply *being*, but being the result of seeing: nature exists as something

10 Cézanne made many such statements. Vollard, for instance, spread the maxim: "Painting is first a matter of visiblity. The content of this art consists of ... what our eyes think ..." Vollard 1960 (as in note 5), p. 82.

11 Cézanne, "la diversité infinie," in: P.M. Doran, (ed.), *Conversations avec Cézanne*, Paris 1978, p. 103.

12 Giorgio Morandi: "As for the rest, I believe there is nothing more surreal, nothing more abstract than reality." This remark can be found in a published interview (of 1957), when he also made use of Cézanne's metaphor of the book of nature that is written in triangles, squares, circles, spheres, pyramids and cones. Morandi associates this observation (correctly) with Galileo Galilei, yet the famous phrase was doubtless also familiar to him from Cézanne. For the interview, see: Lamberto Vitali, *Giorgio Morandi, Pittore*, Milan 1970, p. 97. See also Gottfried Boehm, *Paul Cézanne, Montagne Sainte-Victoire*, Frankfurt am Main 1988, pp. 6off, 120. Morandi's commonly used term, "so-called reality" ("cosidetta realtà"), puts his understanding of reality into quotation marks in general as well.

seen anew every time. Art itself is understood as an undertaking that tests perception, allowing us to assign verifiable content to our vision of reality.

The reversal of the old, long suspect tenet of the imitation of nature was thus definitively completed. Nature did not prescribe an order but art was to create or fathom one through its possibilities and visual approaches. Order is neither invented nor imagined, it results from the act of contemplation, 'sur le motif.' Morandi made this maxim his own and further developed it. The 'model stage,' on which bottles, vases and jars performed as actors will be further discussed below. First a few words about Cézanne's transformed pictorial method. He makes painting into an operation with autonomous elements in which visible things are descriptively 'realised.' This double nature of the picture – to consist of elements and to show a subject – can also be observed in Morandi's work. Its colouristic structure oscillates between formal and figurative; both ways of seeing become interwoven.

IV

Morandi's pictorial concept applies not only to his oil painting but also to his etching, watercolour and drawing. Its resources come to light only once we examine the genuine potential for expression created by changes between different methods and media. The consequent significant differences can but be outlined here, not adequately dealt with.

Morandi's conceptual breakthrough, as indicated above, resulted from his ability to demythologize 'Pittura metafisica' and to make it 'empirical,' i.e. into a matter of seeing. This further development is remarkable in that it was not obvious. Giorgio de Chirico, for instance, moved from 'Pittura metafisica' to neo-classicism. Picasso, on the other hand, had difficulty leaving the 'dead end' of Cubism. Yet he too tended towards depicting monumental classicizing figures in the twenties. Morandi's work of the same period, however, returns to an increased awareness of the act of seeing and of the role of pictorial elements. Naturally he ignored the techniques provided by Seurat or Monet (and Cézanne of course); he made no attempt to assemble reality from spots, dots or amorphous shapes. Morandi preferred to follow the old masters: He worked with tonalities and tried to accompany changes in tones with an overall tonality. He silhouetted objects, thus connecting them to their two-dimensional pictorial equivalents. Similar features can be observed in his landscapes. He not only treats houses like boxes, thereby subjecting them to still life conditions, but also transposes the complex forms of organic matter (trees, plants, bushes), the "diversity" of the hills, valleys, pathways, clouds – that is, the usual repertoire of landscape – into an order of surfaces.[13] The point of this process is to obtain not only a reduction of what is visible in nature to make it visible in a painting, but also an enhancement. In the texture of the paint, in gestural traces, in the landscape character of the pictorial composition (which refers back to the artist, as does the well placed signature) the subject acquires a vivid originality, charm and an aura. A reality of its own lights up. While it may recall

13 See the article by Michael Semff, 'Die späten Landschaften Morandis', in: exhib. cat. Tübingen/Düsseldorf 1989 (as in note 1), pp. 49ff.

14 Giorgio Morandi, letter dated 6 January 1957, in: Lamberto Vitali, *Giorgio Morandi*, Milan 1965.

the real Grizzana, real vases or jugs, it develops anew through the artifical means employed.

We would do well not only to accept the qualitative differences and considerable gap between pictorial form and visible reality (to which the former refers through seeing) but also to understand the productive way in which Morandi transposed one into the other (figs 5 and 6). His aim, after all, was not to depict perfectly familiar visible objects, only imprecisely, apparently unfocused and oscillating, to exercise artistic licence. On the

contrary, his choice of creative vision served the understanding of reality. But what is it that is understood? Morandi's concise statement in a letter of 6 January 1957 is helpful: "The only interest the visible world awakens in me concerns space, light, colour and forms."[14] In other words, whatever appeared before his eyes, depending on the subject, interested him as a manifestation of space, light, colour and form. Other approaches to knowledge (scientific, practical, etc.) are interested in the content or utility of the objects in question. The contrasting nature of artistic understanding can be illustrated by the fact that Morandi ignored physical properties, such as the hardness of a given material, the texture of a surface, etc. They were of no value to his gaze at that which 'is.' It soon becomes clear that space, light, colour and form are also the actual means Morandi uses to transform what he sees into what he paints. Space, light, colour and form are aspects of the visible world as well as creative means. The transposition that comes into play between visually clarified reality and the visual elements of representation consists of the true seeing referred to above, i.e. seeing reality, which is the inevitable authority of this artistic conception.

By the end of the Second World War Morandi's art attains a new level. Besides elucidating the fundamentals he had been gradually developing since the twenties, his late work lends them a definitive clarity, moderate emphasis and sage severity.

Fig. 5 Morandi's studio in Grizzana

Fig. 6 *Still Life*, 1963. Oil on canvas, 30 × 35 cm (V.1323). Bologna, private collection

The analysis of his concept needs to stand the test of an individual work of art. It remains valid in the face of reproaches against Morandi for a lack of variety, major themes or literary background. Such criticism describes an artist who makes studies but lacks the power to produce great work. The small size of his pictures was cited in support of this view to indicate he had no energy or drive for anything great. Isn't this kind of painting prelimin-

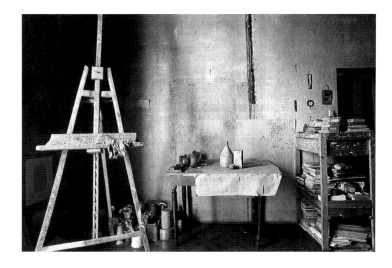

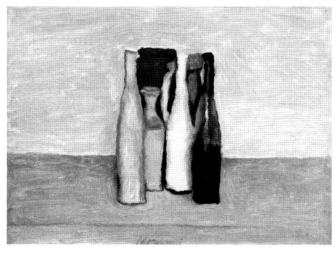

Fig. 7 Morandi's studio in Via Fondazza in Bologna

Fig. 8 *Still Life*, 1957. Oil on canvas, 30 × 40 cm (V.1022). Private collection

ary to painting? Artistic finger exercises of a master without the courage to go further? In fact, the silent witnesses of his work, the repertoire of objects can still be viewed in Morandi's studio today. There they stand, the modest heroes of these small pieces devoid of action, occasionally pre-draped in colour by the artist himself (fig. 7).

Anyone persisting in such disappointment with the limited content has in the end not made use of his or her own eyes. For the true viewer will perceive that the objects are not 'there' at all, but only develop in the picture itself. Some are so thoroughly disguised with a kind of camouflage that they are barely recognizable and can never be clearly identified. They oscillate between figurative and abstract forms (especially in the drawings and the paintings of his late period). They are as elusive as they are self-revealing (plate 87).

In Morandi's pictorial approach, the relationships he establishes between objects are highly significant.[15] They consist of substitutions whereby the objects often sacrifice their independence. After a certain point Morandi began to assemble objects into blocks or configurations. A contour then becomes a boundary shared by two or more objects, both separating and joining them (fig. 8). Boundaries of individual pictorial elements can act independently, creating striking correspondences that are not identical with the mere presence of the objects. Vessels become akin to each other, interchangeable. They become channels, dispersing optical energy as in a complex distribution network. These structures do not copy the forms of the bottles, jugs and bowls,

15 See also the comments by Raimer Jochims on a drawing by Morandi, in: *Giorgio Morandi, Ölbilder, Aquarelle, Zeichnungen, Radierungen*, exhib. cat. Haus der Kunst, Munich 1981, p. 76.

but liberate them from their mere existence, lending them a new intensity and presence, and granting them substantial weight. This applies all the more when the surroundings penetrate a vessel's forms here and there, entering into communication with them. Sometimes it is all but impossible to distinguish the surroundings from the object, the background from the figure. A metaphorical ambiguity gives the sight of banal objects an enigmatic presence.

Morandi explored the free exchange or oscillation between 'surface' and 'depth,' concentrating on the problem of inversion and expressing it

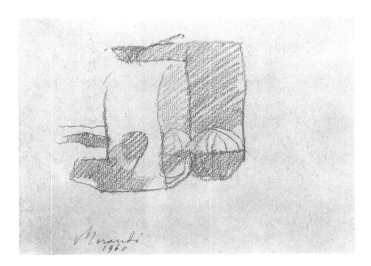 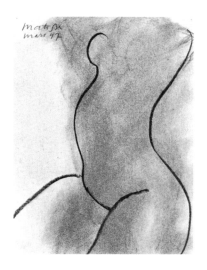

in a new way. In this too he followed Cézanne, who had realised the importance of such relationships – especially in his late works. If it is really true that nature is not endowed with a fixed order, then the system of atmospheric perspective, organising space into clear sequences of receding pictorial planes, ceases to be compelling. Cézanne increasingly replaced it with a flowing transition between pictorial planes. Space in a picture becomes something to be apportioned, arising during the pictorial process and changing shape during its course. It picks up temporal conditions, unfolds in a time sequence. The Renaissance idea of treating perspective as a firmly established system, a kind of given that precedes the composition, the movements of the figures, etc., now loses its credibility and is outgrown.

Such observations substantiate that we as viewers are always caught in a two-fold reading of the picture: reading the arrangement of the forms, we also read their convertibility and vice versa. Morandi not only made use of simple inverted relationships but also assigned new allocations to the foreground, background and in between. This included dividing the background into two or three parts ('fondo bipartito' or 'tripartito'), creating variable arrangements capable of revealing things to the eye very differently. Thus, for instance, a bottle that is lower down can be read both as being 'low' and as a rectangular area. Objects often overlap the pictorial horizon, linking 'above' and 'below.' The lower part of the picture is then reinterpreted: instead of a base, it is a flat rectangle parallel to the picture plane on which the upper rectangle rests. Only the two together constitute the

Fig. 9 *Still Life*, 1960. Pencil, 21.7 × 29.5 cm (T.463). Private collection

Fig. 10 Henri Matisse, *Nude Study*, 1947. Charcoal, 36 × 26.5 cm. Archives Matisse

picture. They create an order in which plane and space interact. Space becomes indistinguishable from the object. Their synthesis surpasses everyday experience, whose perceptual model insists on keeping them separate.

VI

Anyone wishing to understand Morandi's concept will find the drawings especially helpful. Here the artist's creative thought unfolds particularly clearly and boldly. Morandi was not only one of the most perfect etchers of this century, his drawings include him among the ranks – too little acknowledged so far – of its great draughtsmen. In this medium he goes to the extreme. The precarious balance between form and object sometimes comes to a head, hindering any possible interpretation. The viewer starts to puzzle. Morandi does not treat line with elegance. He does not use it as an opportunity for grand gestures, not to mention empty virtuosity. He employs it completely unpretentiously. It feels its way along, breaks off, seems to tremble. His handwriting befriends the objects with each other, and lets them participate in something they are not, but which nevertheless postulates their appearance. Here objects emerge from the shadows, there they dissolve in the brilliance of the paper's surface, here they blend, acquire a common rhythm and a form (fig. 9).[16] All the while, his handwriting remains as open, light and infinitely ambiguous as it was at first glance and will remain for all glances to come. Much more extensive discussion would be required to fully explain the grammar and syntax of his art of drawing.

How peculiarly and masterfully Morandi operates is illustrated by a comparison with Matisse, one of the greatest draughtsmen of modern art. The latter understood the line he worked with as a line of energy. Pressing forward, its force and movement take possession of the pictorial surface, forming objects or leaving them undecided (fig. 10). Morandi's line, as the comparison shows, is not conceived as a trail of energy. Instead, one can imagine it as having originated from light. It is an unstable boundary, prepared to shift, between shadow and object, between an object and its neighbour. Morandi's drawings show how everything participates in the flux of change; his line itself is both this flux and its trace.

VII

In the limitation of Morandi's motifs appears the abundance of his world. As we have seen, there is no need for great inventions or variety in the themes because even the visual events occurring within a single object (with the fluctuations of lighting and human attention) can be called infinite. An almost arbitrary part of reality, an object in daily use, embodies everything that comprises the essence of reality: light, form, space and colour. Their respective dispensation in a work of art gives the everyday object a density and a physiognomy, the engrossed contemplation and unravelment of which occupies the art lover's eye. The advancement of understanding

16 See also Jochim's analyses, *ibid.*

that the artist is after in his work does not in the least concern deciphering this puzzle of appearances, but his increasingly consummate ability to formulate it. The concentration of our gaze, the undistracted attention we are caused to pay, gives the pictures a concentrated stillness and an inexhaustible presence.

The question of what experience and understanding we gain from Morandi's pictures, which we posed when looking at his artistic basis, still lacks a comprehensive answer. Such experience is surely characterised by

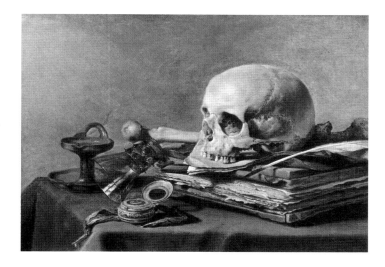

the stillness or speechlessness mentioned above. Even more so, there is a remoteness from words and concepts to these pictures. The silence that emanates from them does not result only from their lack of a message or the paucity of their motifs. It has something to do with the creative fluctuation between the appearances of forms and objects that was described above. In some cases the objects seem to hover instead of stand. The consummate balance between the effectiveness of surfaces and volumes, of colours and contrasts furnishes everyday reality (which we think we know and which is reflected in the subject-matter, especially of the still lifes) with a foreignness and a new, authentic appearance.

Despite the pulsation of the pictorial components, a calm overall impression keeps re-establishing itself. Movement and calm become intertwined. The viewer creates these syntheses: under his gaze pictorial forms become objects and objects colour values, silhouettes and linear constructions. Their oscillation revolves as if on an axis. This vivid structure could hence also be called cyclical. It is a quiet, self-regulated process in which a jug, a bottle or a vase emerge in order to return right back to their original two-dimensional appearances. The objects withdraw into the background and are constantly renewed back out of it, in permanently repeating cycles. This confers and assures presence. Whatever keeps reappearing has more vitality and presence than something created to exist only once, i.e. a mere object. Thus the ordinary objects we recognize in Morandi's paintings and drawings are made to elude transience. This peculiarity of theirs becomes

Fig. 11 Pieter Claesz, *Vanitas Still Life*, 1630 Oil on canvas, 39.5 × 56 cm. The Hague, Mauritshuis

clearer when we compare it to the nature of earlier still lifes (e.g. from 17th-century Holland), in which the emphasis on transience predominates (fig. 11). For Morandi time is a positive, revealing element. He thus reverses the meaning of the earlier still lifes (inasmuch as it consisted of demonstrating transience). The cyclical nature of time we experience in his pictures witholds corruption from the objects. *Vanitas* or *memento mori* is not what they are about. They are islands of calm that provide their own stability and balance. Precisely because time flows back into itself in them, as it were, renewing itself, they cannot be shaken by the power of negation. "Stillness takes on the contours of a bowl, a bottle, a pitcher ..." as Walter Helmut Fritz wrote in his poem on Morandi. This tranquillity does not come from just anywhere. It is created in the picture itself, thanks to the oscillation introduced into it. Hence we must end by using a paradox to express the nature of the experience the viewer derives from these works: time "holds on" in their tranquillity. It has lasting substance. From our experience with life we only know a kind of time that passes, a time in which the present represents a vanishing limit. In his pictures Morandi lets us participate in a temporal order which is optimistic and immaterial at the core of its experience. The objects are as disembodied as they embody themselves. In the midst of fleeting time the artist is able to create a place with solidity and presence.

By investigating Morandi's artistic concept we are not trying to find exhaustive answers.[17] We intend to provide aids for viewing his pictures and impetus for thought. In the light of the above considerations, many a preconceived notion and prejudice about Morandi that has been in vogue becomes considerably obsolete and in need of revision. We now not only have the opportunity to find out more precisely what modern art consists of (its semantic import, its significance). We must also decide what kinds of experience are worthwhile, which are going to survive the hour or the day, or the unreliable prompting of the zeitgeist. Morandi's art represents a delicate and human power, that of a "great minor master" (Jochims).

17 See also Gottfried Boehm, 'Morandis Stilleben', in: exhib. cat. Munich 1981 (as in note 15), pp. 51ff, especially pp. 59f.

The Paintings

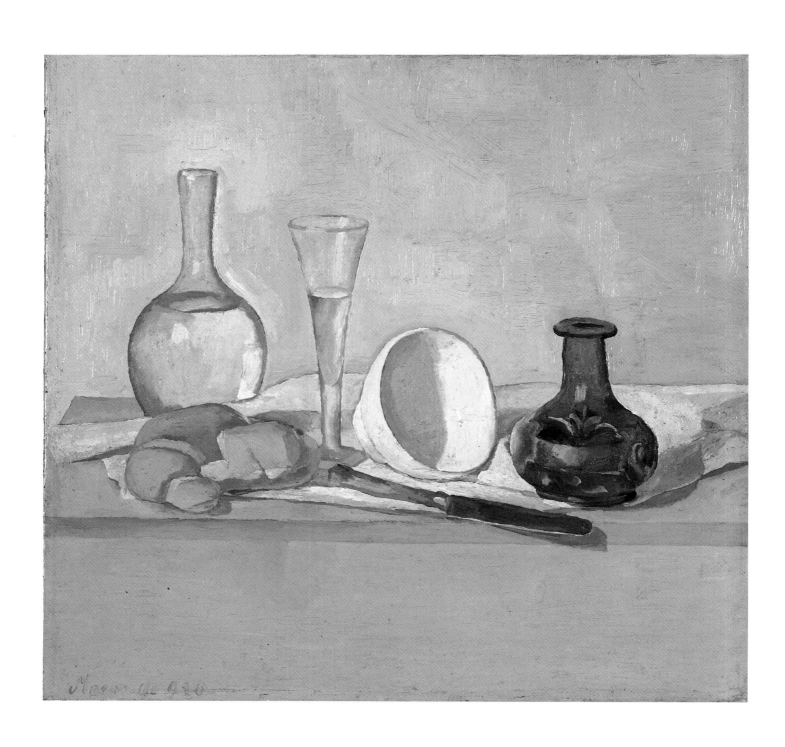

1 Still Life, 1920

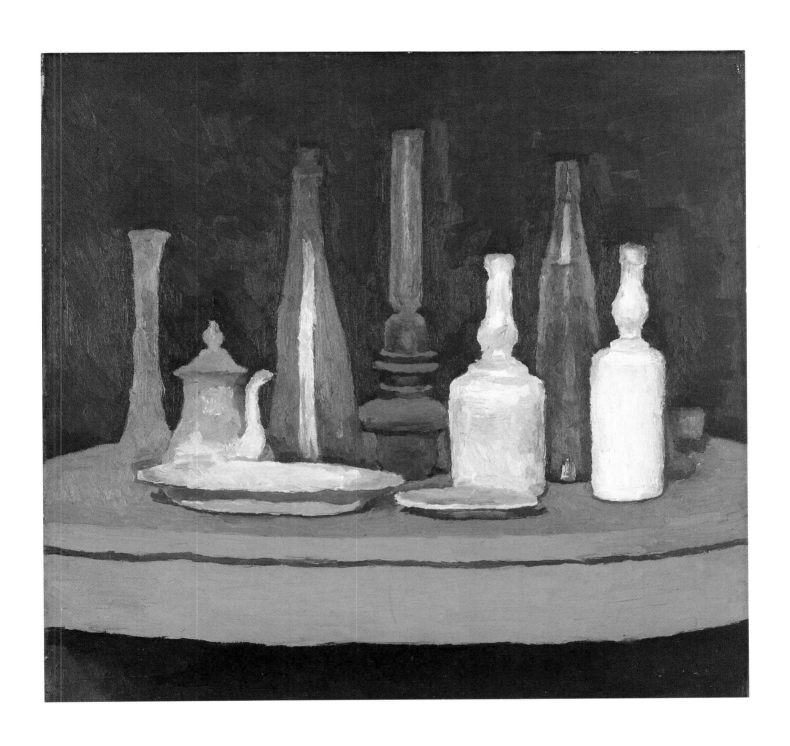

2 Still Life, 1929

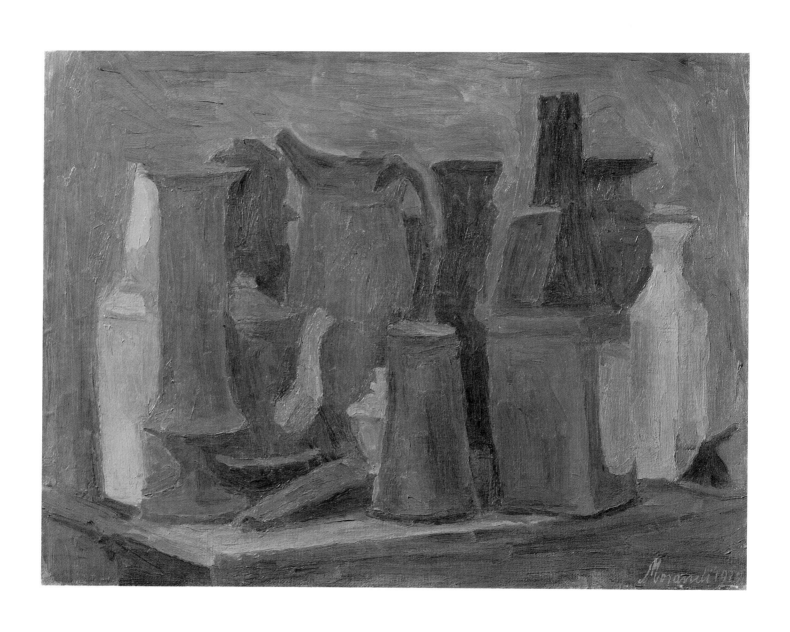

3 Still Life, 1924

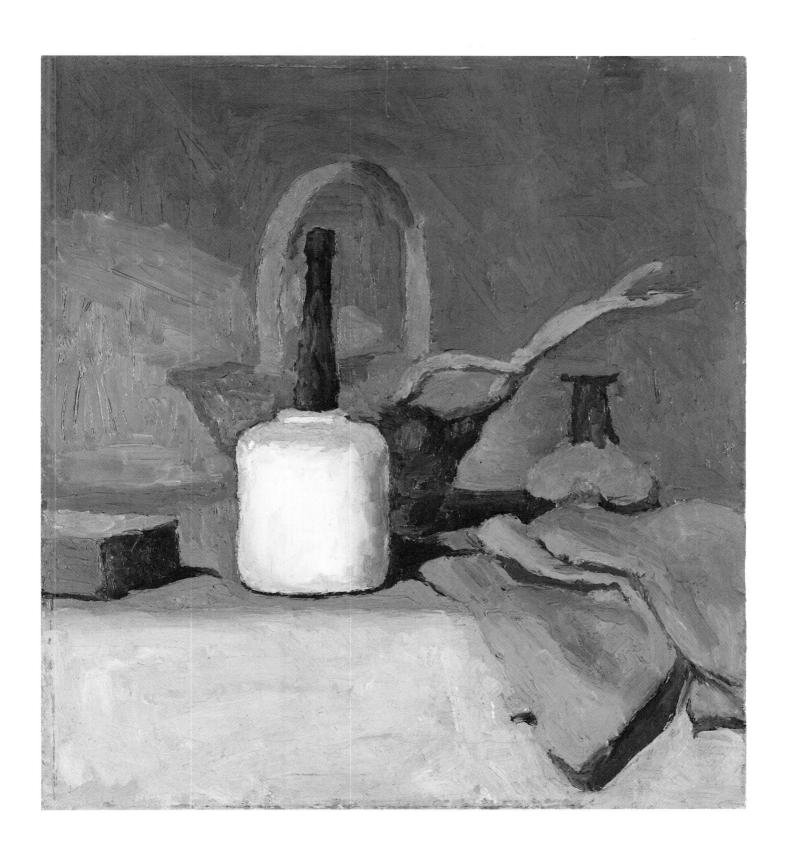

4 Still Life, 1929

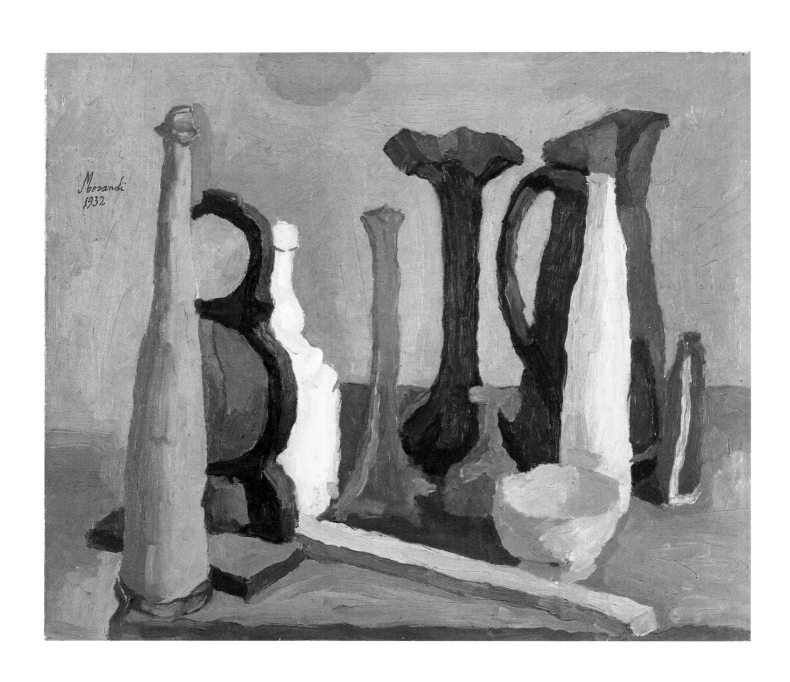

5 Still Life, 1932

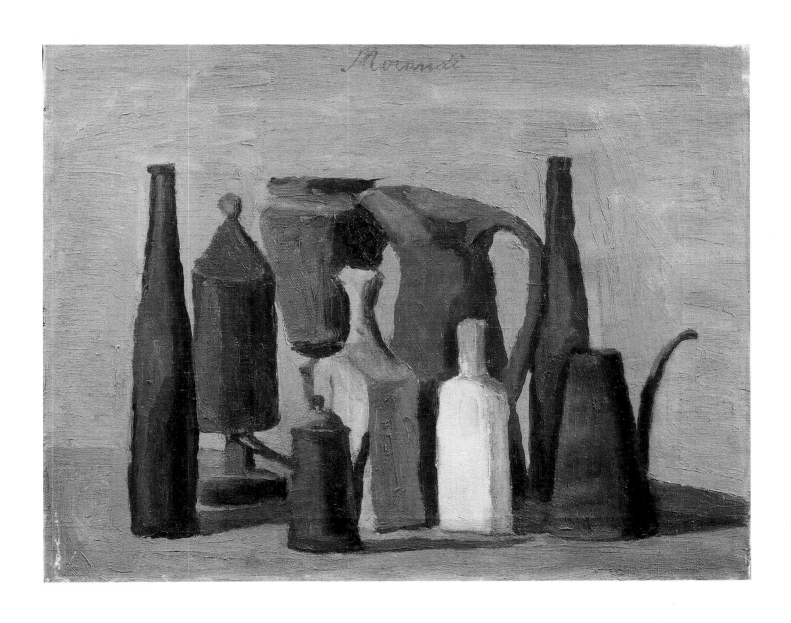

6 Still Life, 1940

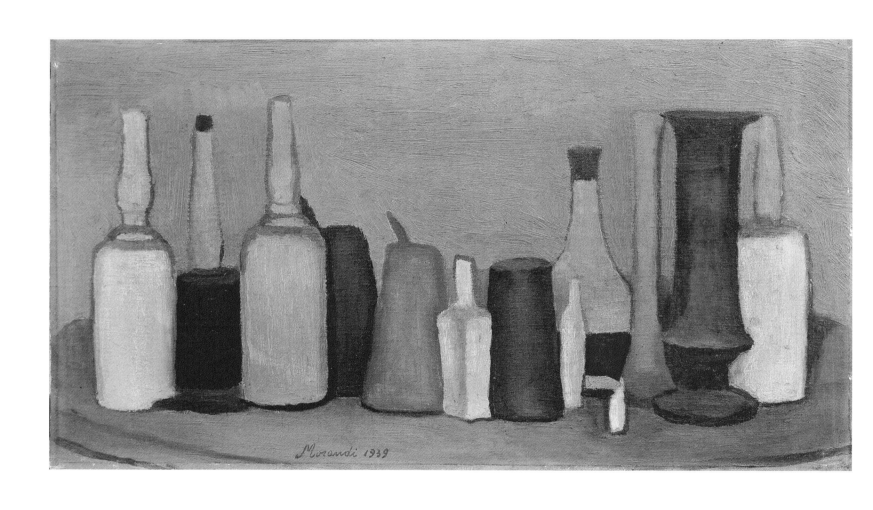

7 Still Life, 1939

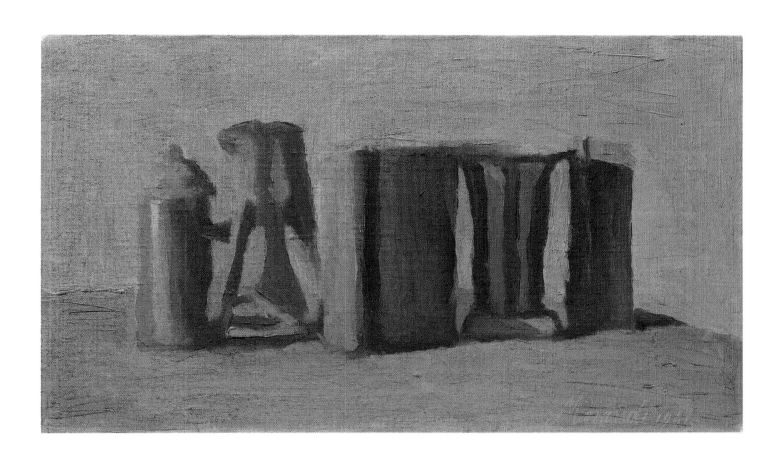

8 Still life, 1941

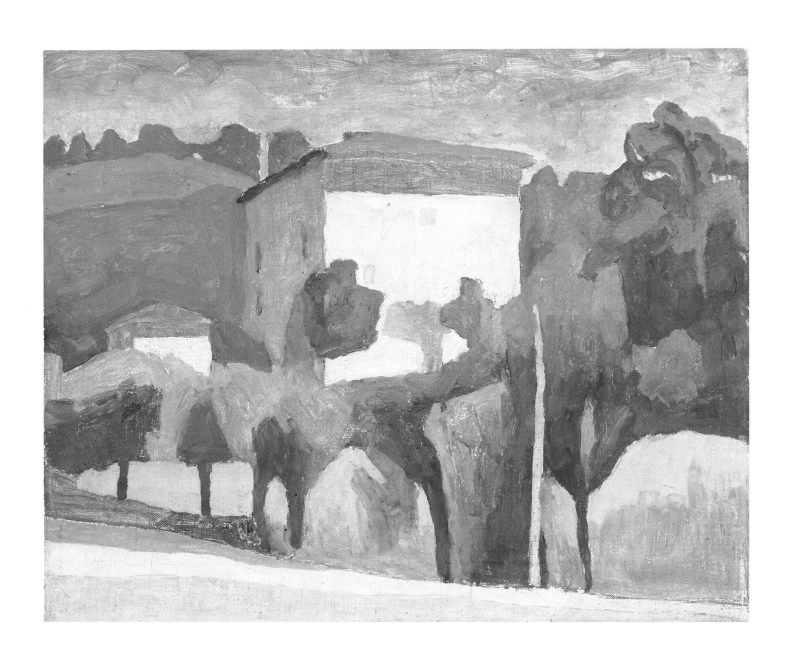

9 Landscape, 1936

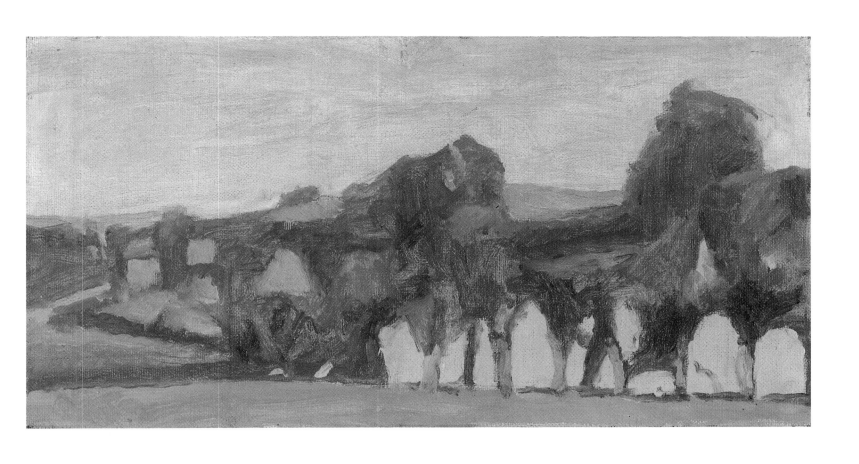

10 Landscape, 1942

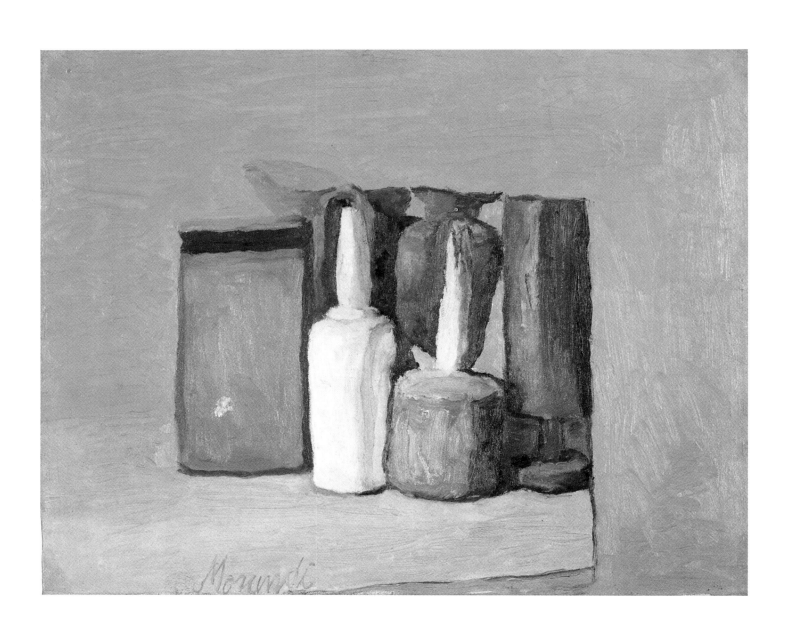

11 Still Life, 1949

12　Still Life, 1949

13　Still Life, 1955

14 Still Life, 1957

15 Still Life, 1958

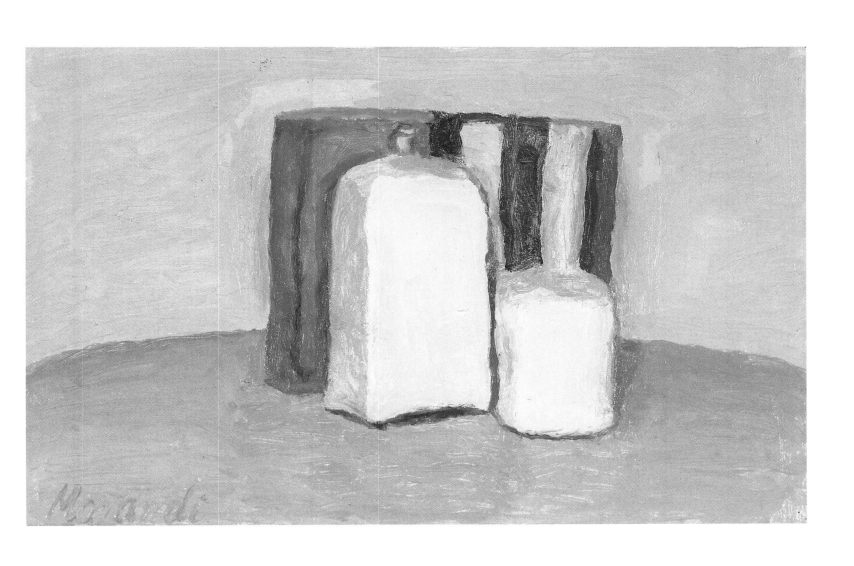

16 Still Life, c. 1957

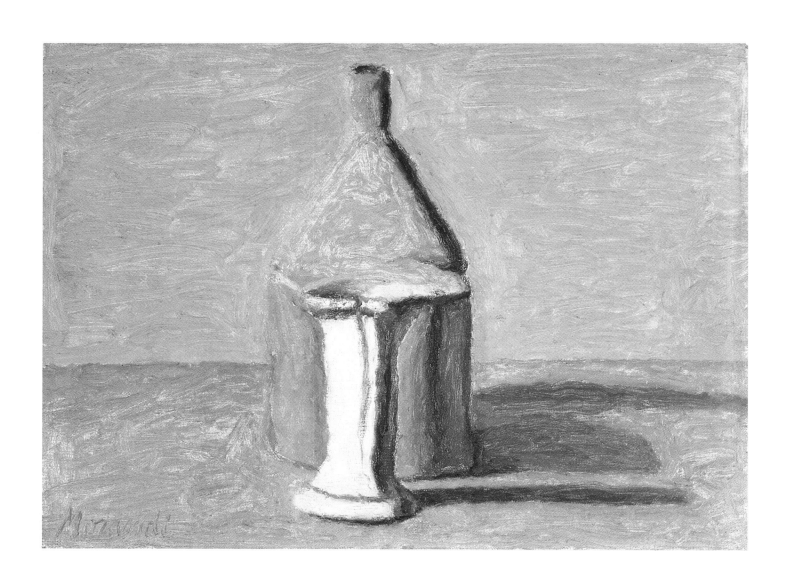

17 Still Life, 1960

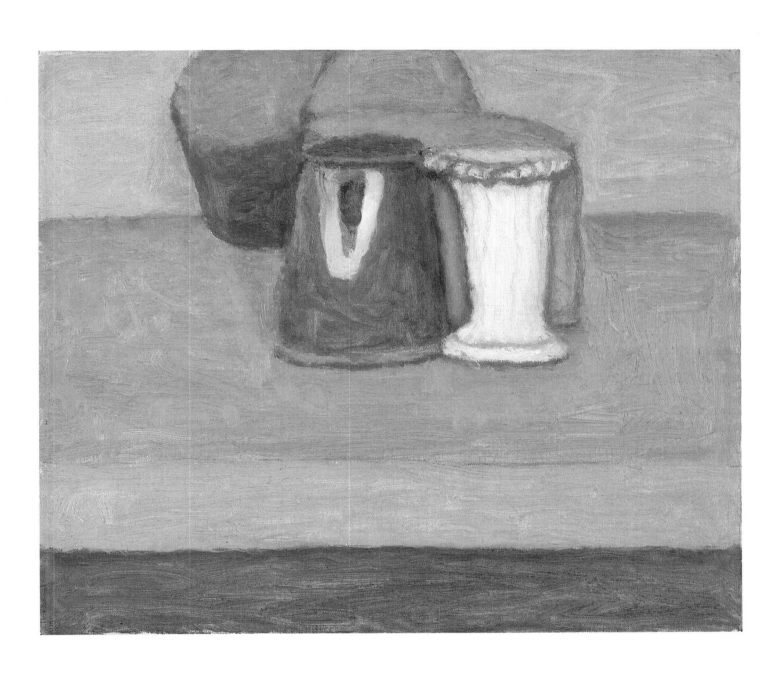

18 Still Life, 1960

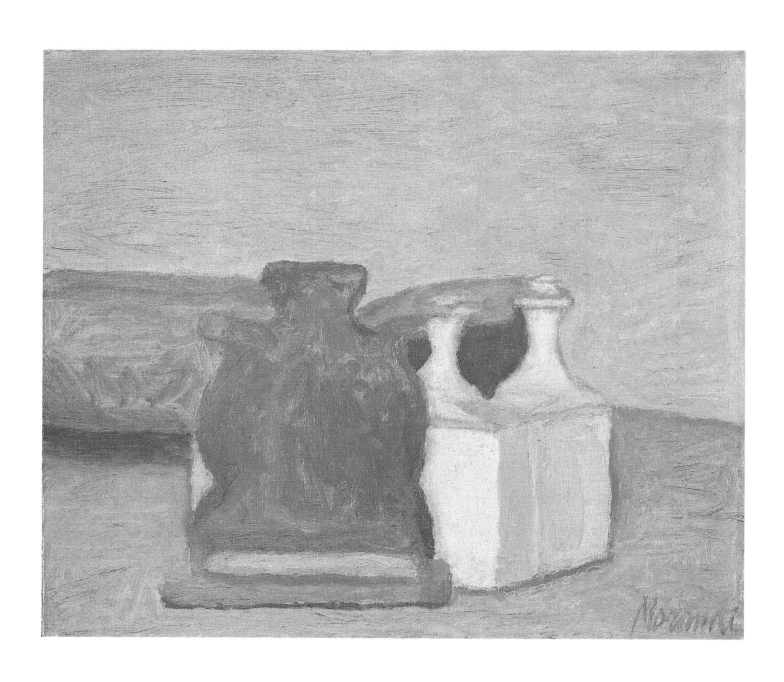

19 Still Life, 1960

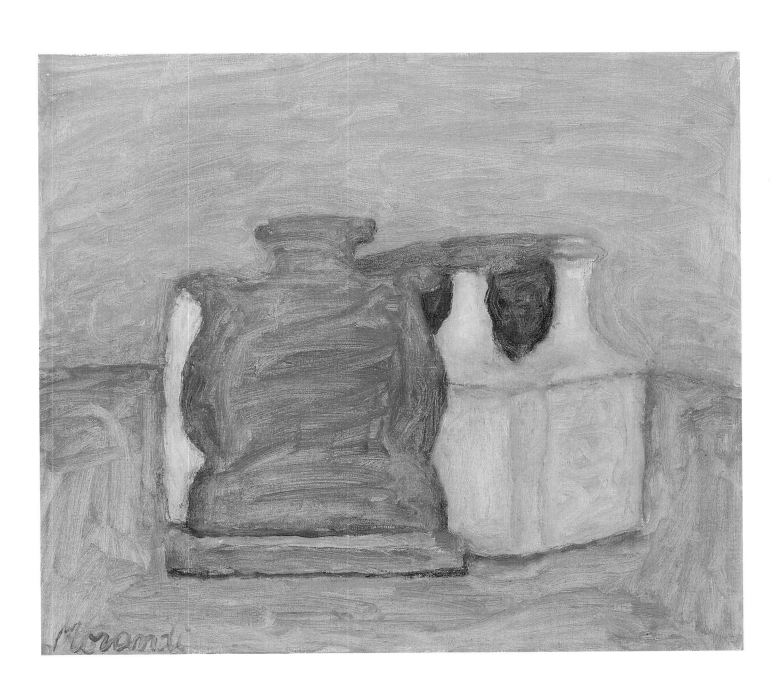

20 Still Life, 1963

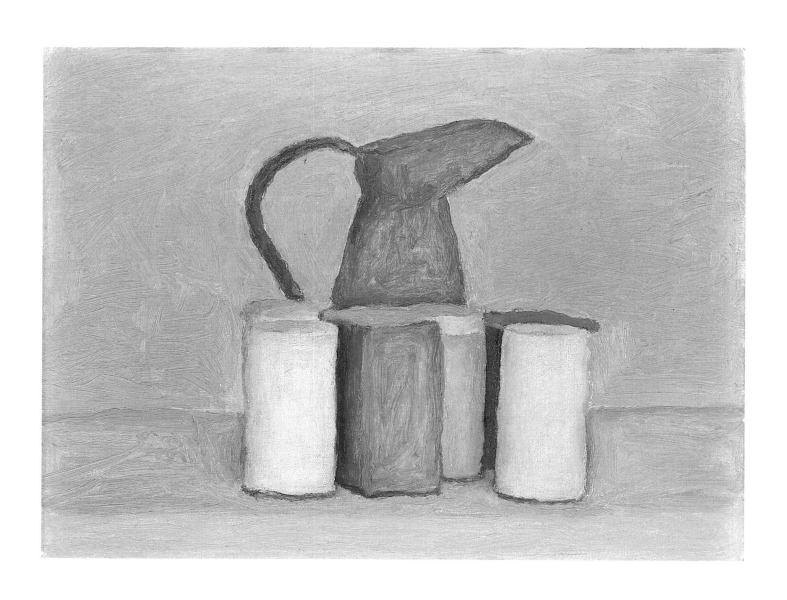

21 Still Life, 1960

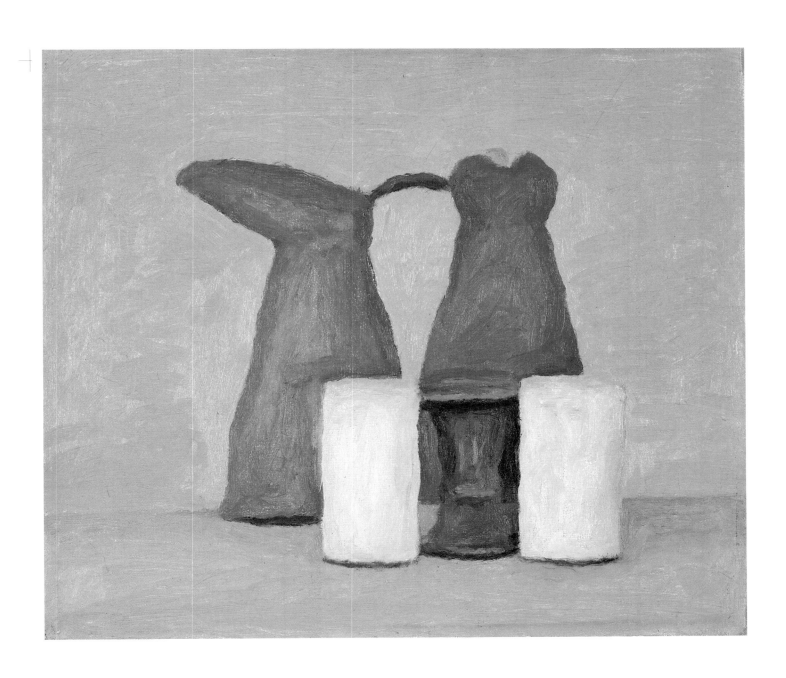

22 Still Life, 1962

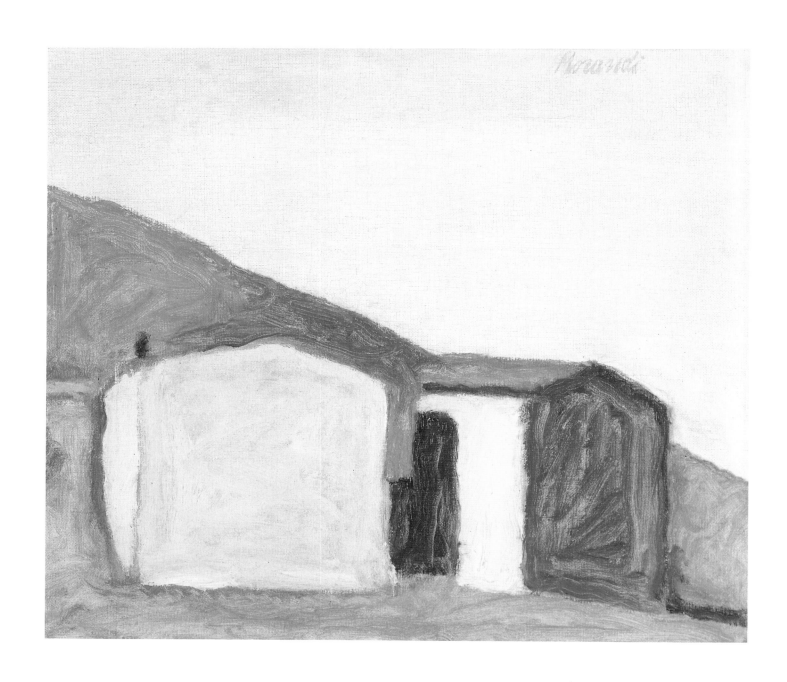

23 Landscape, 1961

24 Landscape, 1961

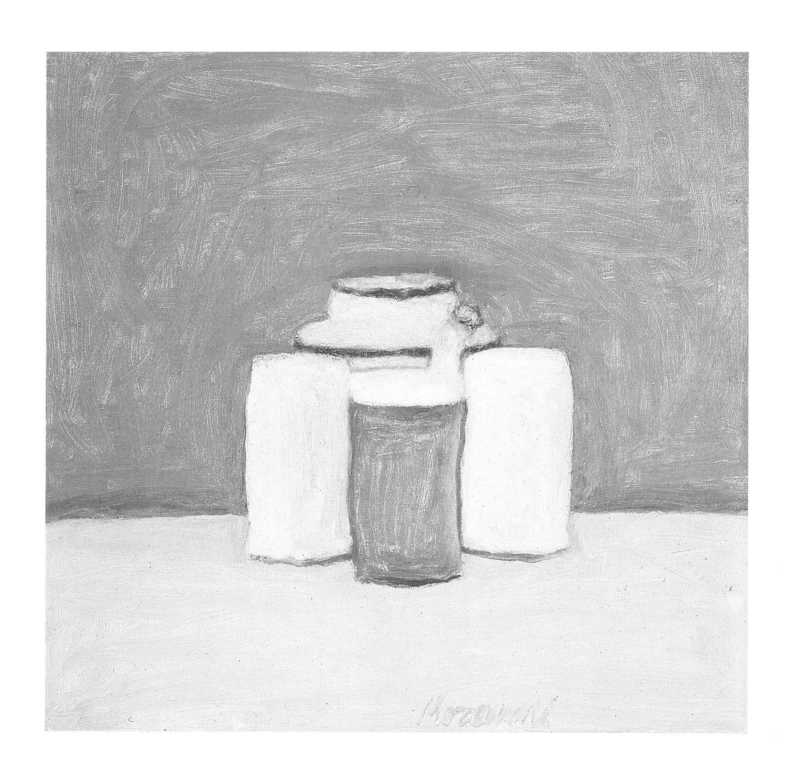

25 Still Life, 1962

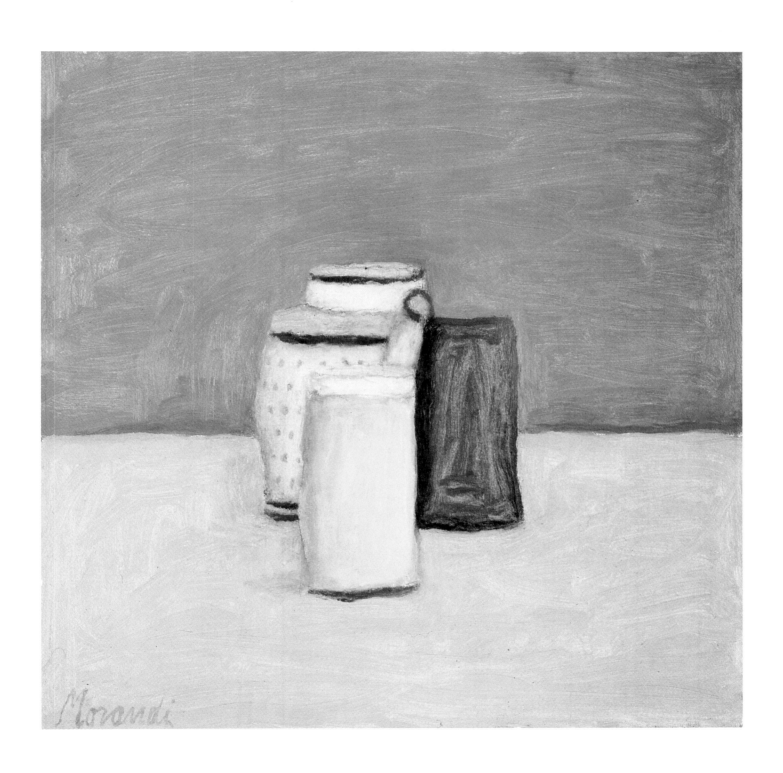

26 Still Life, 1962

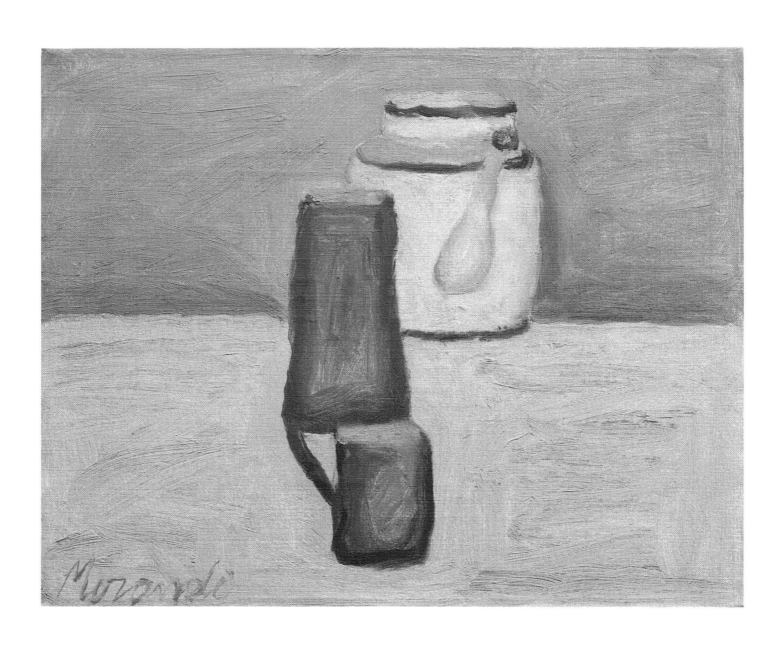

27 Still Life, 1962

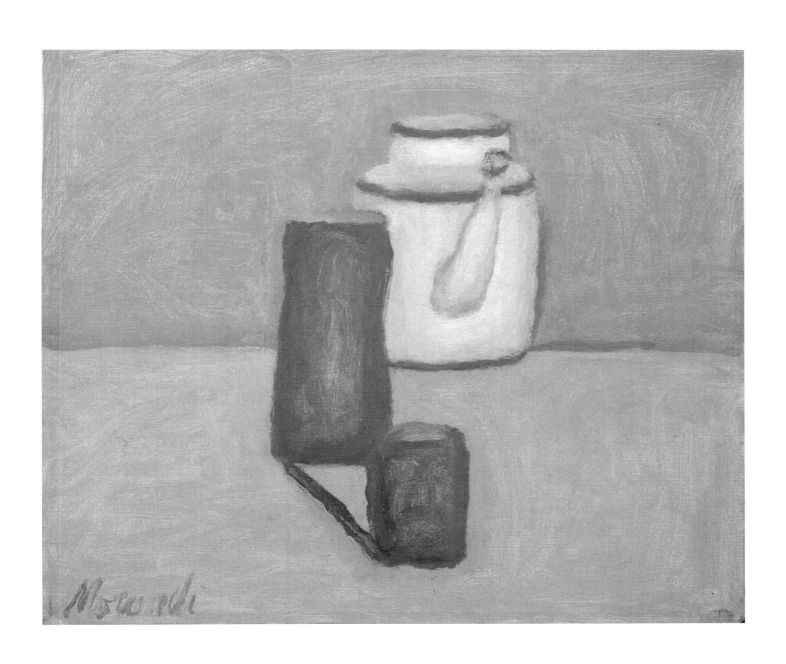

28 Still Life, 1962

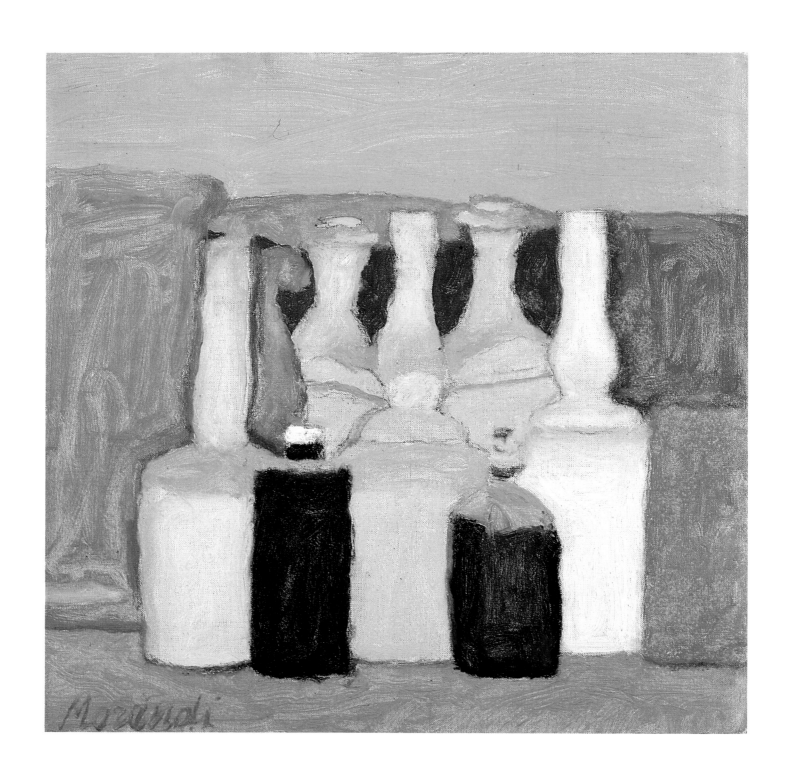

29 Still Life, 1962

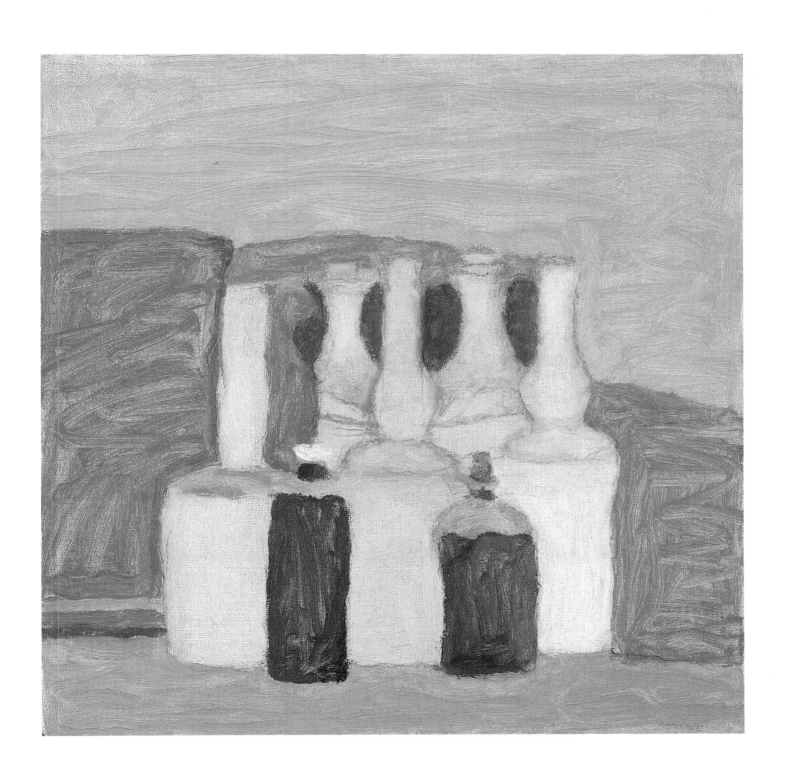

30 Still Life, 1962

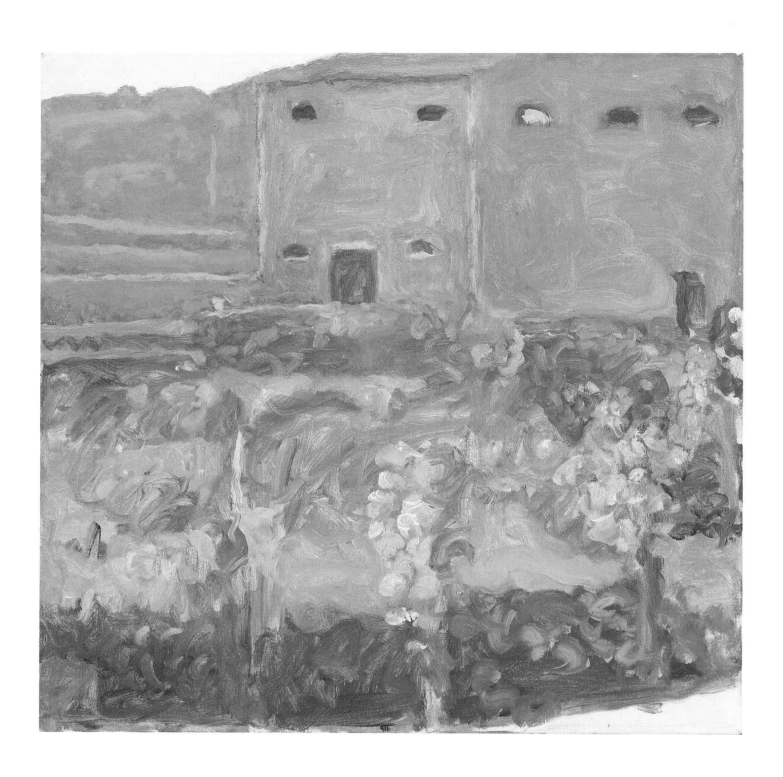

31 Landscape, 1962

32 Landscape, 1962

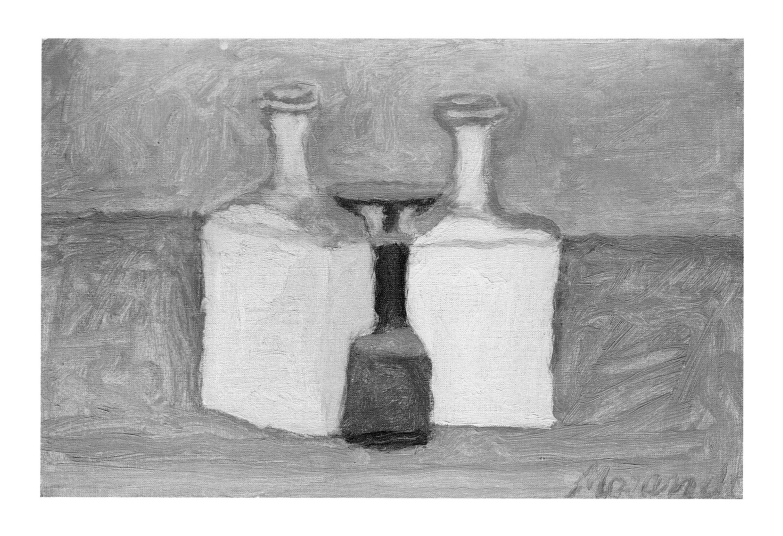

33 Still Life, 1963

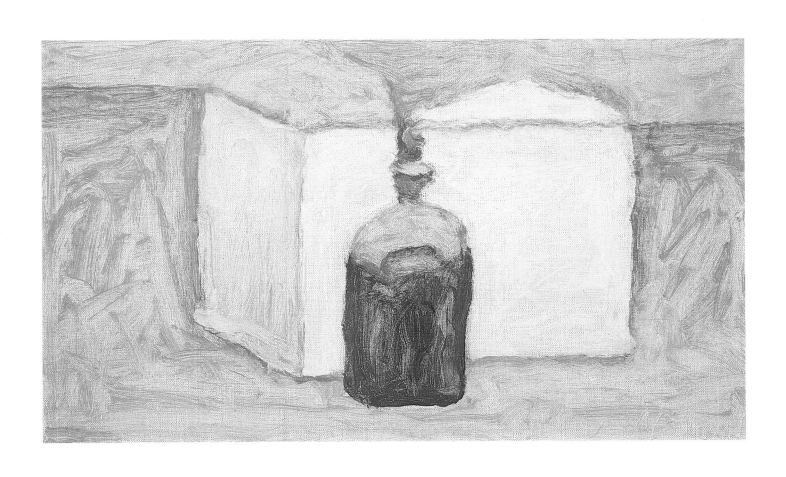

34 Still Life, 1963

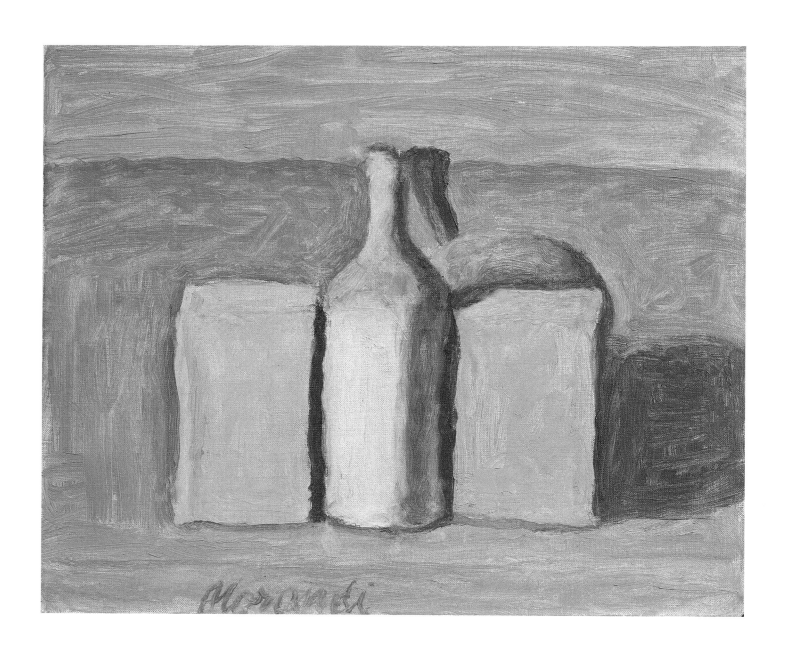

35 Still Life, 1963

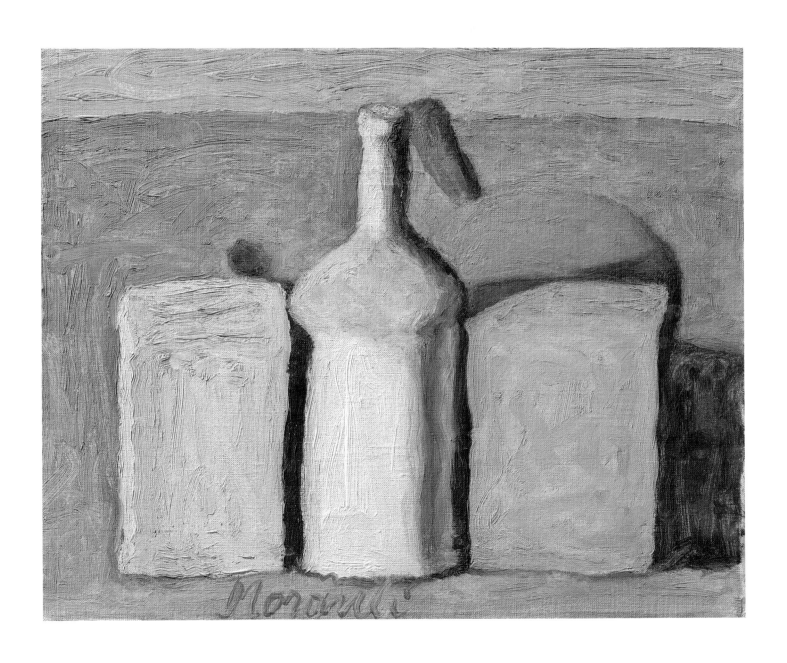

36 Still Life, 1964

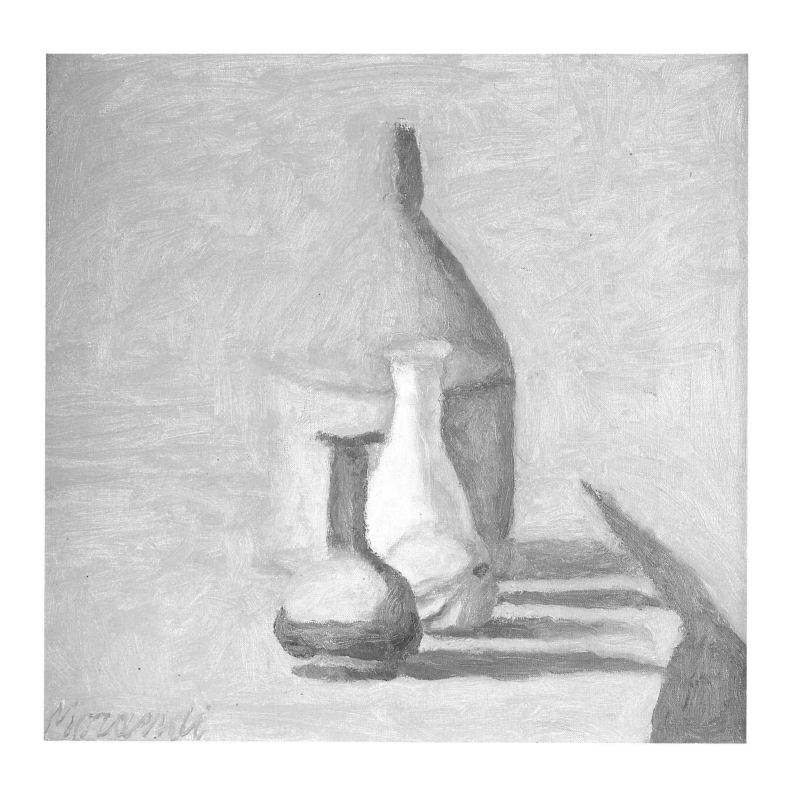

37 Still Life, 1963

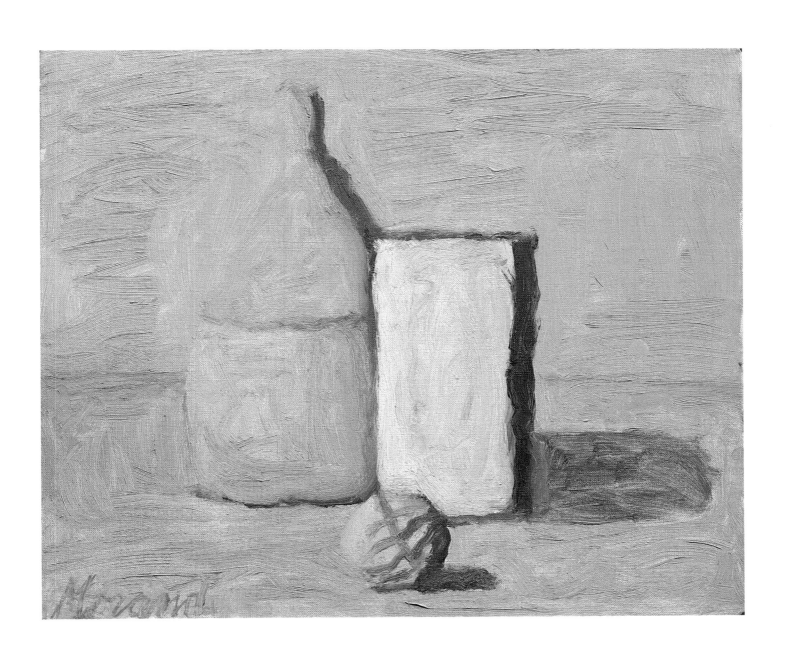

38 Still Life, 1964

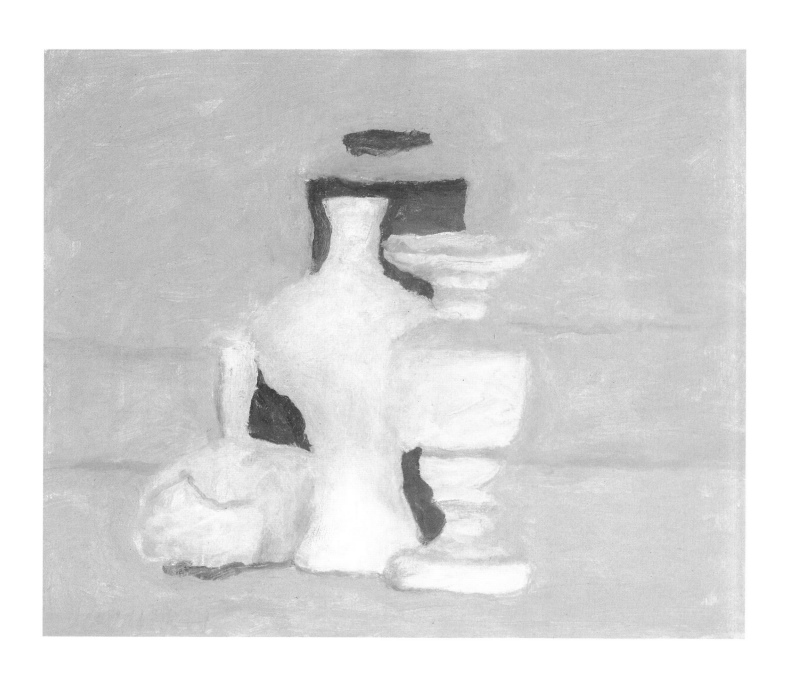

39 Still Life, 1963

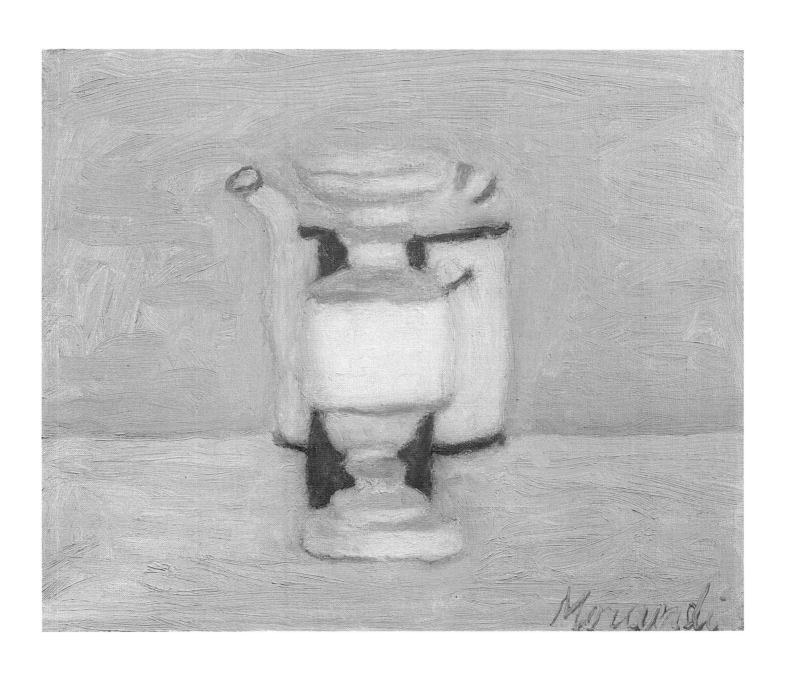

40 Still Life, 1963

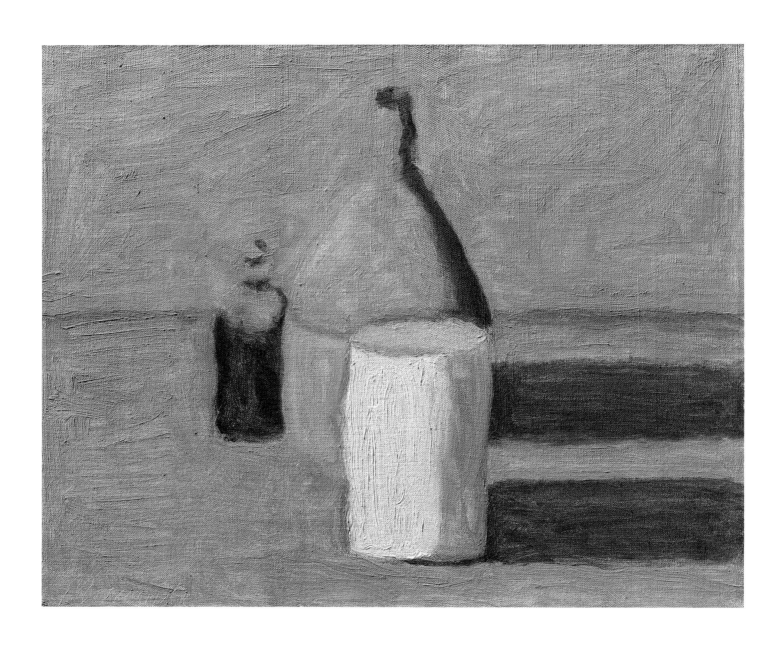

41 Still Life, 1963

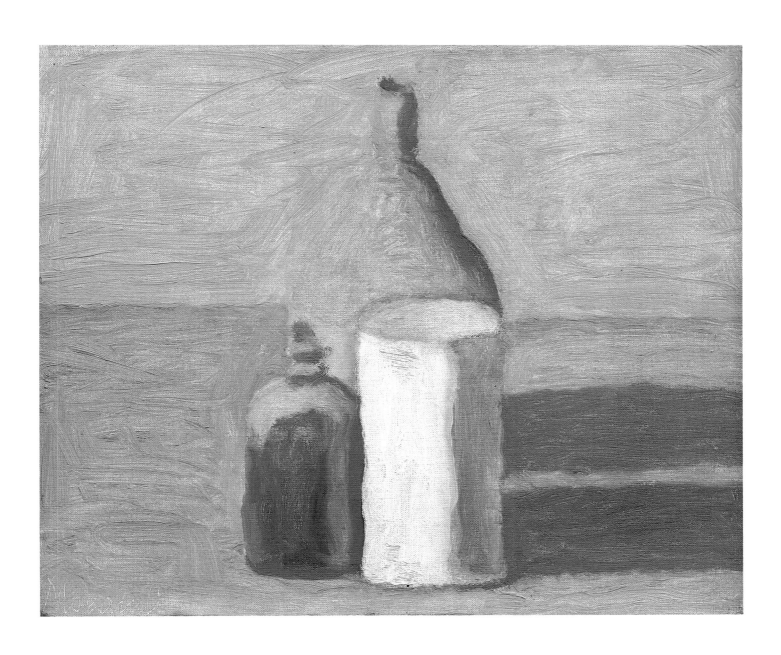

42 Still Life, 1963

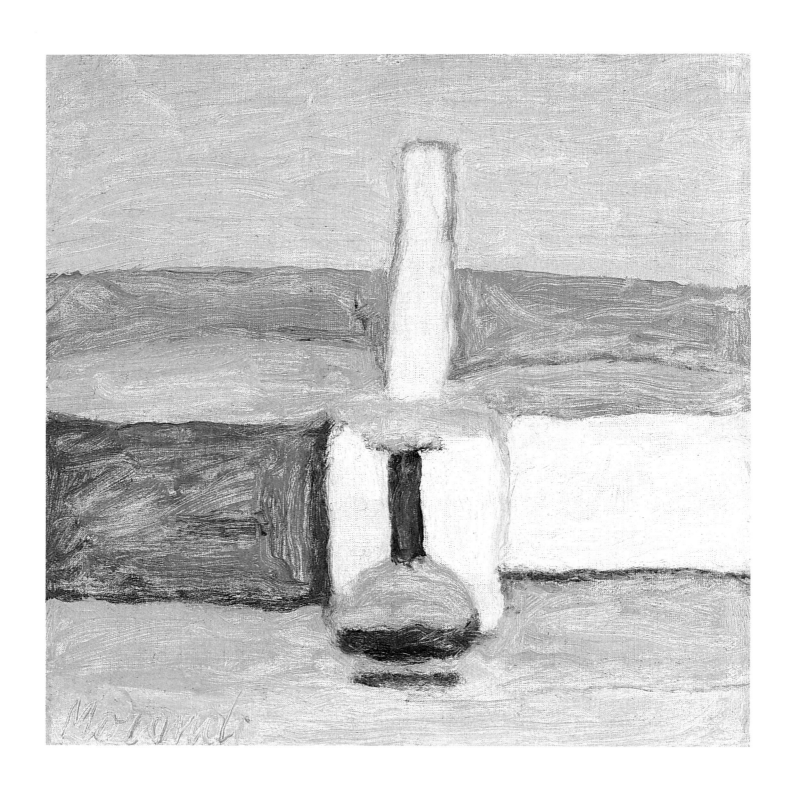

43 Still Life, 1963

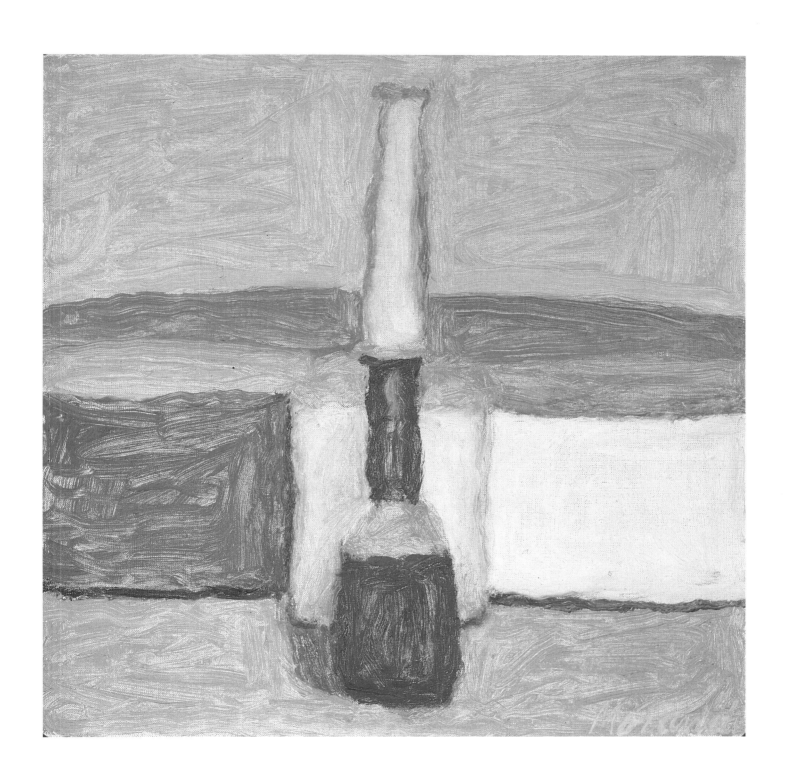

44　Still Life, 1964

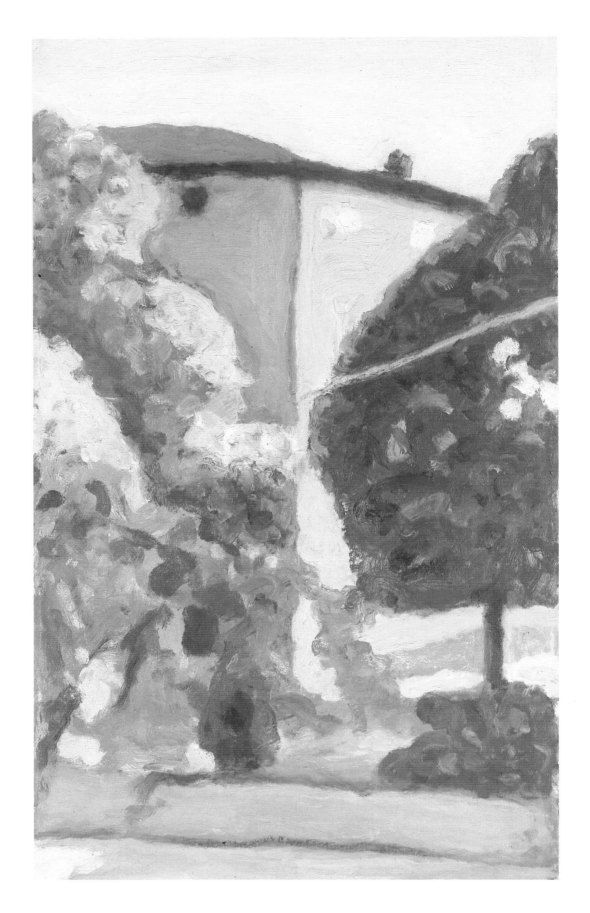

45 Landscape, 1961

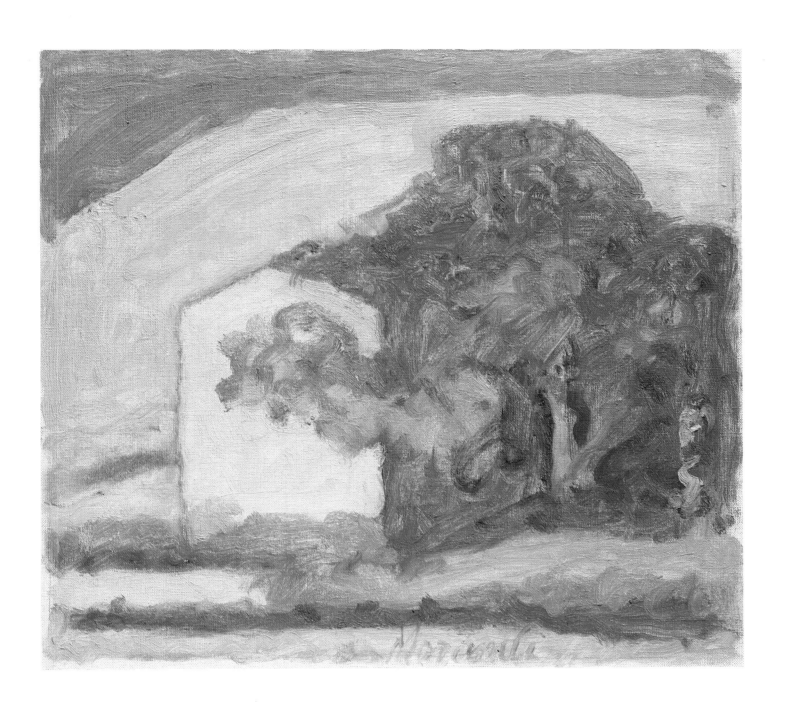

46 Landscape, 1963

47 Landscape, 1963

Ernst-Gerhard Güse

The Watercolours
of Giorgio Morandi

The exhibition of Morandi's watercolours that took place at the Giorgio
Morandi Galleria Communale d'Arte Moderna in Bologna in 1990-91, as
well as the publication of the catalogue of the complete watercolours edited
by Marilena Pasquali emphatically demonstrate the current interest in this
body of his work. Though it may suggest itself to rank Morandi's works
in order of artistic technique, it would be inappropriate to consider water-
colour, drawing or even etching as minor media in his oeuvre and to rele-
gate them to a mere secondary status. Morandi himself commented: "They
mean the same to me; the only difference is in the technique actually used,"
and emphasised his interest in the "peintre-graveurs," "whose etchings
were as great masterpieces as their oil paintings."[1]

 Morandi's works on paper are by no means to be understood as prepara-
tory works for paintings. Independent and having equal rights, they are part
of a single artistic creed. Moreover, his still lifes and landscapes in whatever
technique refer solely to what is depicted. They are conceived exclusively
under artistic aspects. Anything programmatic, referring beyond the repre-
sentation itself, is excluded. "I believe more in art for art's sake," Morandi
said, "than in connection with a religion, social justice or national glory.
Nothing is more foreign to me than an art that serves other purposes than
those of art alone."[2] Metaphysical and even psychological dimensions were
allowed to prevail as little as mythological and literary references. The ob-
jects themselves, the shapes of everyday life, detached from any meaning
normally given them by the viewer's consciousness, are the objects of
Morandi's unswerving attention. E. Roditi applied the concept of "objective
abstraction"[3] to Morandi's art, contrasting it with the subjective abstraction
of Mondrian that shuts out reality. These aspects, which are decisive for
Morandi's artistic concept, are what give his works unity. They are the foun-
dation of the equal rank that all his works enjoy as a matter of principle.

 The publication of the complete catalogues of Morandi's paintings in
1977, his drawings in 1981 and 1984, and his etchings in 1991 provides an
opportunity to comprehend more precisely the individual groups of works
in Morandi's oeuvre in terms of their dimensions and their possible inter-
relationships. In a survey of Morandi's production, Franz Armin Morat
referred to the significance of his late works. They greatly exceed the works
of his earlier years, not only in quantity but above all in quality. "Nowhere
else does one encounter the astonishing fact that a painter only got started
in the fiftieth year of his life. Morandi's complete works consist of 1,360 oil
paintings, ... Before 1940 he produced fewer than 248 oils, that is less than
one fifth of the total. After turning 60, Morandi painted almost as many as

1 Edouard Roditi,
Dialoge über Kunst,
Wiesbaden 1960,
pp. 142–143.

2 *Ibid.*, p. 132.

3 *Ibid.*, p. 134.

in all the previous decades put together."[4] This observation is certainly confirmed by the watercolours. The catalogue produced by Marilena Pasquali lists only 32 watercolours for the years from 1915 to 1953, while between 1956 and 1963 there were as many as 224. Consequently, Morandi painted the majority of his watercolours in the last eight years of his life. This can hardly be interpreted as a coincidence, considering that in 1956 Morandi retired from his position as a professor of etching at the Academy of Bologna, which he had held since 1930 and which served to secure his livelihood. Freed from teaching, he could concentrate fully on his own work until his death in 1964.

The corpus of watercolours is introduced by one painted in 1915 (fig. 1), which contains but few references to Morandi's late work as far as the theme is concerned. It is more of a coloured drawing than a true watercolour: the page is covered with a group of fashionably dressed ladies, moving into the depth of the picture. Although there is no reference whatsoever to a setting, the scene suggests a street. This is surprising, considering Morandi's oil paintings of this period. Morandi was familiar with Cézanne's work from reproductions, he had participated in the *Prima Esposizione Libera Futurista* in 1914, and in his still lifes of 1914-15, which indicate his orientation on Picasso and Braque, he had drawn near to Cubism. This clearly identifiable context of his still lifes in oils scarcely seems to relate to the watercolour in question. Nevertheless, the composition of this watercolour – characterised by the three-dimensional overlapping of the figures – exhibits an obvious proximity to the compositions of the still lifes of his late period. Yet another element presages design features of his late watercolours: the combination of unpainted areas with those exclusively composed of colour.

The human figure also predominates in his subsequent watercolours of April and June 1918 (P.1918 1, P.1918 2). These are related to his paintings of 1914–15 depicting bathers and clearly demonstrating their derivation from Cézanne. His encounter with Cézanne's work has often been traced: Morandi knew Cézanne's works from black-and-white reproductions in the book by Vittorio Pica, *Gl'impressionisti francesi* (1908). He saw original watercolours in 1914 at the *Second Secession Exhibition* in Rome and later, at the 1920 Biennale in Venice, he was introduced to Cézanne's oil paintings as well. According to himself, it is especially his works between 1912 and 1916 that display the influence of Cézanne. "An artist's early works are almost always finger exercises, and teach him to apply the principles of the older generation until he attains the maturity to be able to express himself in his own style," was Morandi's comment on his works of those years.[5] As far as his watercolours of 1918 are concerned, their proximity to Cézanne lies in the subject-matter and in the free treatment of the proportions, which follows its own laws instead of an ideal imposed on the picture from outside. Morandi simplifies, stylises and, with the tall format of his watercolours, attains an almost "Gothic" conception of the figure. Derain, Archipenko and Modigliani have also been cited in this context. Lehmbruck's sculptures were not yet known to him at the time. In fig. 2 the figure and the background are given the same treatment, both in the

4 Franz Armin Morat, 'Introduction', in: *Giorgio Morandi. Ölbilder, Aquarelle, Zeichnungen, Radierungen*, exhib. cat., Haus der Kunst, Munich 1981, p. 11.

5 Roditi 1960 (as in note 1), pp. 130–131.

6 Carlo Carrà, *Pittura Metafisica*, Florence 1919. Quoted in: Pier Giovanni Castagnoli, 'Die künstlerischen Anfänge Morandis', in: *Giorgio Morandi, 1890–1964, Gemälde, Aquarelle, Zeichnungen, Radierungen*, exhib. cat. Kunsthalle Tübingen, Kunstsammlung Nordrhein-Westfalen, Düsseldorf, Cologne 1989, p. 30.

colour and in the distribution of light and shadow. Space is so reduced that there is at most a relief-like effect.

The cactus watercolour of July 1918 (P.1818 4) points in a different direction as far as this aspect is concerned. It is the first still life among Morandi's watercolours and repeats a motiv depicted in an oil painting a year earlier. In its clear distribution of light and shadow and – contrary to the painting – its scarcely defined space, it exhibits almost sculptural effects. The cactus still life dates from the months between the spring of

1918 and the autumn of 1919, when Morandi – especially in a series of paintings – shows an affinity to 'Pittura metafisica.' In 1919 C. Carrà wrote: "It is the 'ordinary things' that have such a beneficial effect on our spirit, causing it to attain the highest peaks of delight and grace. Anyone desisting succumbs inevitably to absurdity, nothingness, both physically and spiritually ... Only the ordinary things reveal those forms of simplicity that refer us to a higher state of existence, that state which constitutes the whole comprehensive secret of art ... And because it is impossible to speak any other way than through signs, we focus our attention on this meaning of serene poetry and leave false dreams of the miraculous to vulgar, peasant natures."[6] It was Carrà's ideas on the object as the focal point, not the search for dimensions hidden behind objects (as for de Chirico), which remained important for Morandi's further development. After a brief association, he soon left 'Pittura metafisica' again.

Also dating from 1918 are his first watercolour *Fiori*. These rigidly composed still lifes have little that is specific to watercolour about them in their painting style. They too are defined by clearly articulated, sculpturally emphasised forms. The colours of the flowers are barely differentiated from those of the vase and the background. The composition seems lifeless, as though carved in stone. Despite having been painted during the period when Morandi was connected to 'Pittura metafisica,' his watercolour still lifes of 1918 are far removed from his contemporary oil paintings with their characteristic mysterious boxes, marionettes and magic objects. Rather, they

Fig. 1 *Figures*, 1915. Watercolour on paper, 25 × 37 cm (P.1915 1). Bologna, private collection

Fig. 2 *Bathers*, 1918. Watercolour on paper, 21 × 16 cm (P.1918 3). Milan, private collection

are related to a series of flower still lifes in oils that he had begun as early as 1916.

In 1920 he completed two watercolours whose dark colours associate them with paintings of the same year. In shades of brown, the paint shows the brushwork, thus differentiating these works from previous ones. The composition is now determined by several objects. They are depicted without any overlapping, in a straight row parallel to the picture plane. Areas of light and shade model the objects, raising them from the identically coloured background.

Watercolours continue to appear rather sporadically in Morandi's oeuvre in the years that follow. There is *Arlechino* of 1926 (P.1926 1), for instance, whose subject-matter indicates his contact with Cézanne's pictorial world at the Venice Biennale in 1920. However, not only are there few watercolours from the twenties but also Morandi was restricted in his creative work as a whole during this period. Being in material difficulties, he was forced to take on the very demanding job of primary school teacher.

The *Still Life* of 1928 in the Kunstmuseum Bern (P.1928 1) also reveals his closeness to Cézanne, not least in the drapery overlapping the edge of the table. Two oil paintings dated 1927 (V.115, V.116) are closely related to this watercolour. Only the bottle in front of the basket has changed position in the watercolour, where a bit of the edge of the basket now shows over its left shoulder. An etching of this still life dating from 1927 already exhibits this alteration with respect to the oils. The oils and the etching of 1927 together with the watercolour of 1928 form a coherent group. It is not to be understood as a development process. Rather, each version has its own validity. The row of objects parallel to the picture plane of the watercolours of 1920 has now been replaced by an arrangement of the objects behind each other on a narrow stage-like surface. The drapery now designates the picture plane, while the wall closes off the shallow depth. The dark colours showing the brushwork of the watercolours of 1920 have been superseded by pale, luminous tones, taking away the solidity of the objects.

How the volumes of glasses, vases and jugs dissolve into areas of light and shadow is illustrated in two watercolours of 1943 (e.g. P.1943 3, fig. 3). The overlapping objects, decipherable only with difficulty, are viewed from below, which further contributes to the re-shaping of reality. "I believe there is nothing more abstract and unreal than what we actually see."[7] This comment of Morandi's, in which he expresses doubt in the cognizability of reality, can be reconstructed in a special way in a watercolour such as his *Natura morta* of 1943. Marking off the solid objects with outlines has been abandoned; the three-dimensionality of their appearance is reduced by alternating flat strips of light and shade. References to space on the one hand and the reduction of the spatial dimension, or the emphasis on two-dimensionality, on the other, both characterise the composition. This results mainly from the relationship of the staggered objects to the horizontal surface they stand on. The surface itself shows no dimension of depth. Instead, its horizontality and flatness are further underscored by another surface diagonally sloping rightwards. "In any case it should be kept in mind that Morandi does not simply paint 'objects' in his pictures," as

G. Boehm comments, "but that he lets the objects arise before our eyes, with the help of our gaze, from the relationships between surfaces. And also that the physical objects thus formed are able to retransform themselves back into parts of a surface, which virtually take on the function of a matrix, of a potential," only to conclude that: "In Morandi's still lifes we do not see objects but the conditions for creating objects …"[8]

In the *Fiori* of 1946 (P.1946 1) the focus of the floral still life has shifted to the flowers, leaving only the upper edge of the vase in sight. This type of

flower still life was repeatedly taken up by Morandi both earlier and later. It is dominated by line. The line incorporates the whiteness of the paper, making it an integral part of the image. In the almost non-figurative character of this watercolour Morandi is far from the floral still lifes of 1918.

Line also plays a decisive role in the other still lifes of the same year. There is often an element of tension between the light underdrawing in pencil and the applied watercolour. In the watercolour P.1946 2, the contour line appears both as a colour accent and as a pencil line. Line means both contour and shadow at the same time. The coexistence of both functions of line creates an openness as far as defining the objects in the picture is concerned. This is emphasised by the impression of fragmentariness, of nothing being fully formulated. Hence the bottle on the left in the watercolour only appears in a suggested outline that does not describe the vessel in its entirety. As clearly as the watercolour may be showing that the objects are standing behind each other, here again it turns out that upon closer inspection this impression starts to waver. The contour line of the caraffe on the right incorporates the bowl in front of it. This common line brings the front and the back closer together, even interweaves them. The viewer is

Fig. 3 *Still Life*, 1943. Watercolour on paper, 24 × 33 cm (P.1943 3). Medolla, private collection

Fig. 4 *Landscape* (Courtyard in Via Fondazza), 1956. Watercolour on paper, 31 × 21 cm (P.1956 12). Bologna, private collection

encouraged to look actively at the picture. He himself is what makes the still life appear. He completes it.

Yet it is not the ambiguous relationships between the surface and the space alone that define Morandi's watercolours. There are further relationships that take place within the pictures, between the upper and lower parts. The watercolour P.1946 3 clearly indicates the base supporting the vases and bottles. But this surface contains no spatial reference. As the lower part of the picture it has been clearly highlighted by a colour accent. In this respect it is opposed to the upper part, which has been coloured very sparingly, showing the preliminary pencil drawing.

Also in 1946, Morandi painted his first watercolour landscapes. He had spent the war years almost entirely in Grizzana. There are numerous oil paintings of landscapes from this period, but no watercolours. On the subject of landscape in Morandi's oeuvre G. Briganti commented: "Numerically speaking, Morandi's landscapes constitute only about one quarter of his entire output. However, this striking imbalance as against his still lifes (and flowers) begins only after 1944, while in the preceding years the number of his landscapes is only slightly smaller than that of his still lifes. Apart from the period of his earliest efforts, when his landscapes are even in the majority (many, however, were evidently destroyed by the artist himself), the war years of 1940 to 1944 are the time when Morandi paints most of his landscapes."[9]

When Morandi paints watercolours of landscapes in 1946 (P.1946 8-10) he treats the landscape motif freely and arrives at the threshold of complete abstraction. The majority of landscapes in Morandi's oeuvre consist of the relationship between a house – that is, the structural world of forms – and vegetation. The latter, painted spontaneously and in apparently erratic patches of colour, contrasts with the former. This also applies to *Paesaggio* (P.1946 8), a watercolour that is based on contrasts and determined by light and dark, structural and organic forms, horizontals and verticals.

Landscape – to Morandi this only too often means the view out of the window of his studio in the Via Fondazza. In 1956 Morandi repeatedly depicted it in watercolour (P.1956 9-12). As in earlier still lifes, the same scene, here a view across bushes and trees in the courtyard to the walls of the houses opposite, acquires new aspects of design through minor alterations. The focal point is always the wall of the house towering above the bushes and strictly divided into a zone of bright light and a zone of shadow. This wall becomes increasingly prominent in the different versions. In the watercolour in fig. 4 it is brought up close to the viewer, the structural lines of the architecture contrasting with the irregular application of green.

This formal contrast remains in evidence in the watercolours that depict nothing but groups of trees (plate 51). Common to this series of works are the horizontals of the pathway and the verticals of the tree trunks. They provide a structural framework, as it were, for the composition, while the leaves and branches merging into each other form a counterpoint that opposes colour to line. The effect of these watercolours is produced basically by the varying distance between the vertical elements that are the tree trunks. The question of the composition's vertical or horizontal layout acquires decisive importance. The vertical arrangement of the motif

9 Giuliano Briganti, 'Morandis Landschaften', in: exhib. cat. Tübingen/ Düsseldorf 1989 (as in note 6), p. 45.

10 Bernhard Growe, '"Cosidetta realtà": Die Unverfügbarkeit der Welt, Serialität und Lichtgestaltung in den Stilleben Giorgio Morandis', in: exhib. cat. Munich 1981 (as in note 4), p. 67.

11 *Ibid.,* p. 70.

on the horizontal paper gives it a horizontality; the element of tension, resulting from the increasing distance between the groups of trees, grows. In addition, the zone of the branches and foliage claims the viewer's attention.

Slightly later, in 1958, a group of watercolours (P.1958 19-23) appears that is close in conception to those of the previous year. Here too, construction and free design, line and colour come together. The structural elements are what provide orientation in terms of the objects. The obvious predominance of formal elements in his watercolour landscapes and the clarity of their composition, in no way inferior to the still lifes, place Morandi's watercolour landscapes far from anything to do with romantic empathy. And while his numerous versions of an individual landscape site may suggest the Impressionists' work, such as Monet's representations of the Cathedral of Rouen, any notion of temporal change is out of the question in Morandi's art. Its formal certainty seeks permanence.

Another series of watercolour landscapes from 1957 depicts a factory building with a chimney against the background of a wooded area (plate 49; P.1957 12-22). As though observed from a distance, the objects lose their contours and their existence in space. Instead, a soft sfumato joins them together. Two treetops emerge from the flat green of the wood. Together with the chimney, they form the verticals that supply this composition with concrete orientation and accent it. Here too, the horizontal of the light complex of buildings can be seen as the surface – comparable to the table in the still lifes – upon which the relationship between forms and colours occurs.

An almost complete negation of objective form eventually appears in a series of watercolours dating from 1958. They are characterised by alternating violet and light, unpainted areas that appear to dissolve the architecture and everything static (plate 52; P.1958 11-18). Only the green colour of the area above the architecture creates a link to reality, alluding to tree tops above houses. A connection has often been noted between Morandi's watercolours and Oriental ink-and-brush paintings. This refers to the meditative character of his watercolours and their spirituality, the results of his penetration of reality, instead of a direct formal connection.

The ultimate extreme of transformation is shown in a watercolour landscape of 1958 (P.1958 11). Light and colour compose a rhythm of organic patches, in which objects can only be identified with the help of related works. "For Morandi the foundations of this visible world, which are all he is interested in, without seeing in them anything like an unshakable norm of artistic endeavour, are form, colour, space and light."[10] This observation by Bernhard Growe similary applies to Morandi's landscapes and still lifes. Furthermore, in form, colour, space and light Growe saw the actual themes of Morandi's pictorial series. A series results from his repeated attempts to find a new integrated whole. Not least the late watercolour still lifes, in their ever new approaches to reality, strive to compose their disparate nature in the picture into an integrated whole. "At the end of the artistic and perceptual process, whose point of departure was such a definite and simple set of premises, the immediate presence of the objects and the steadfastness of the world end up being questioned with a calm – and thus all the more persistent – deliberateness," observes Bernhard Growe in conclusion.[11]

The Watercolours

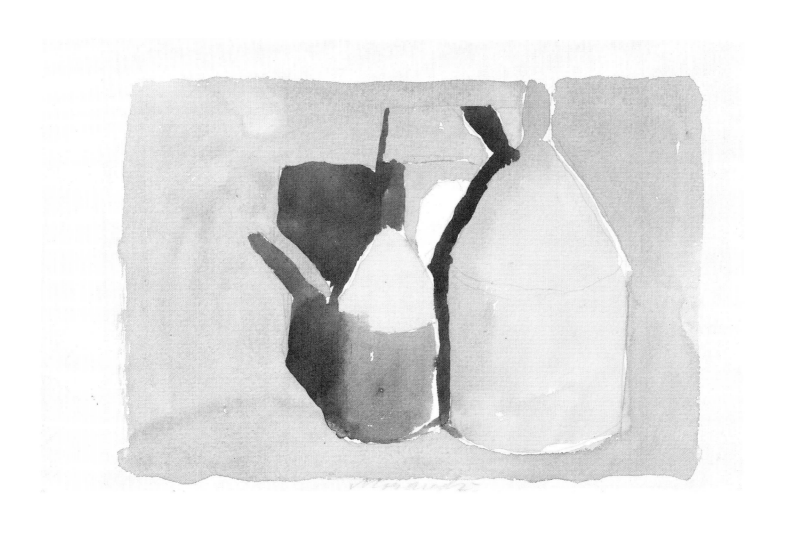

48 Still Life, 1956

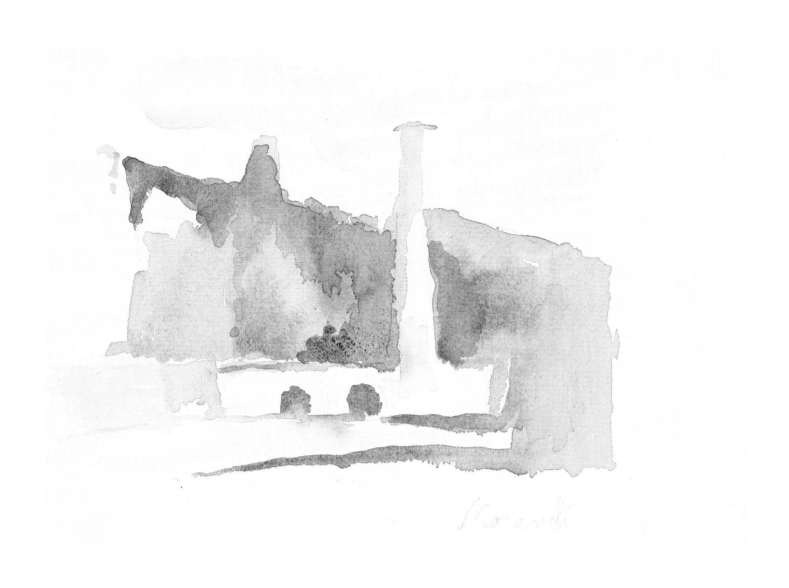

49 Landscape, 1957

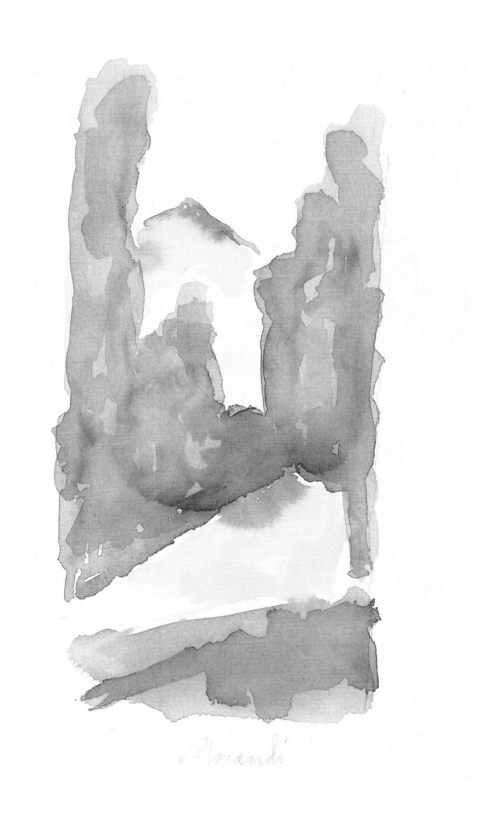

50 Landscape, 1958

51 Landscape, 1957

52 Landscape, 1958

53 Still Life, 1958

54 Still Life, 1959

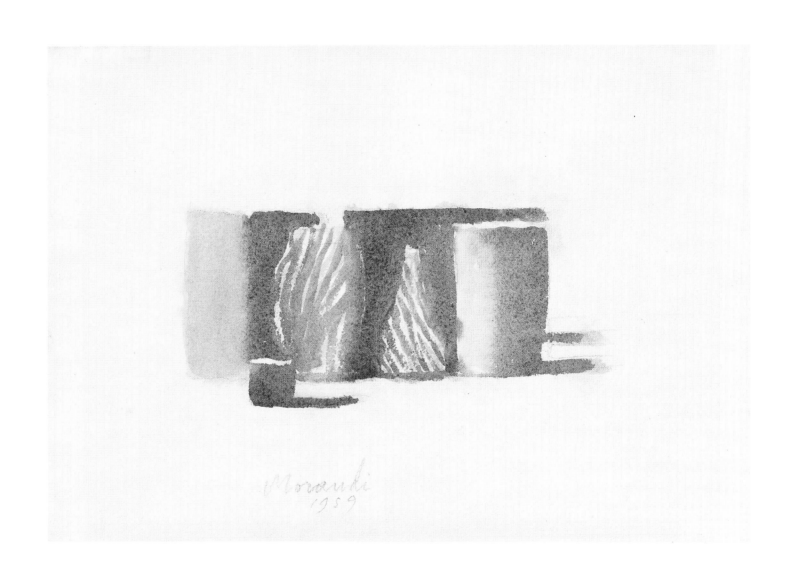

55 Still Life, 1959

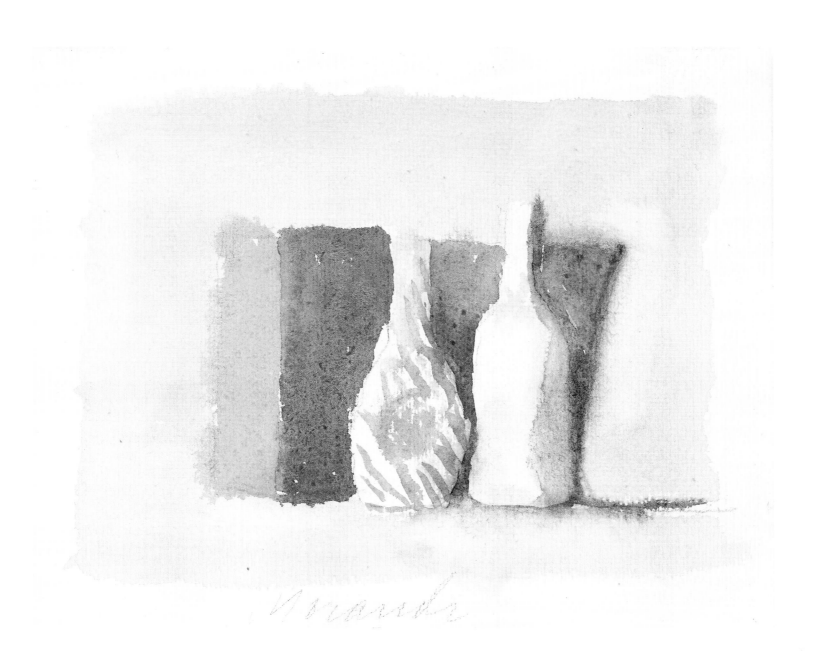

56 Still Life, 1959

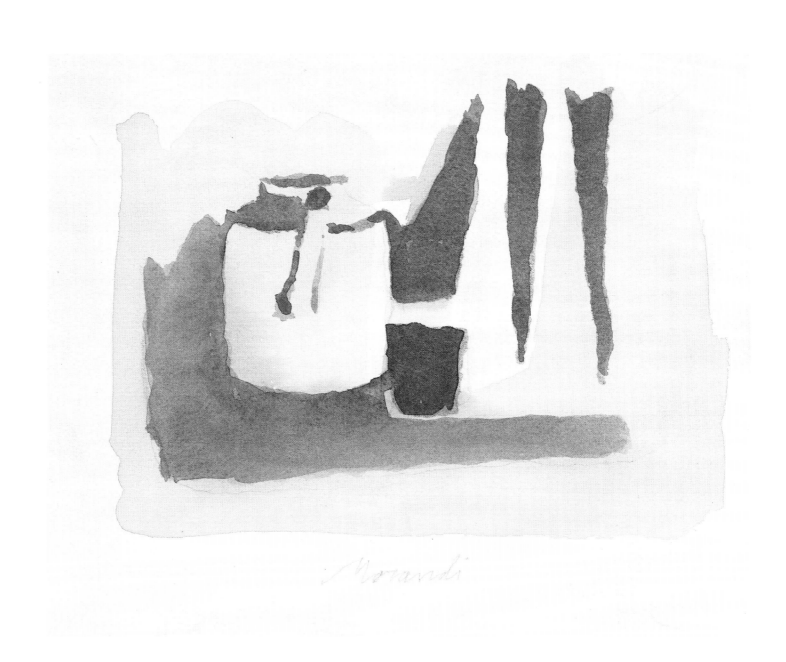

57 Still Life, 1959

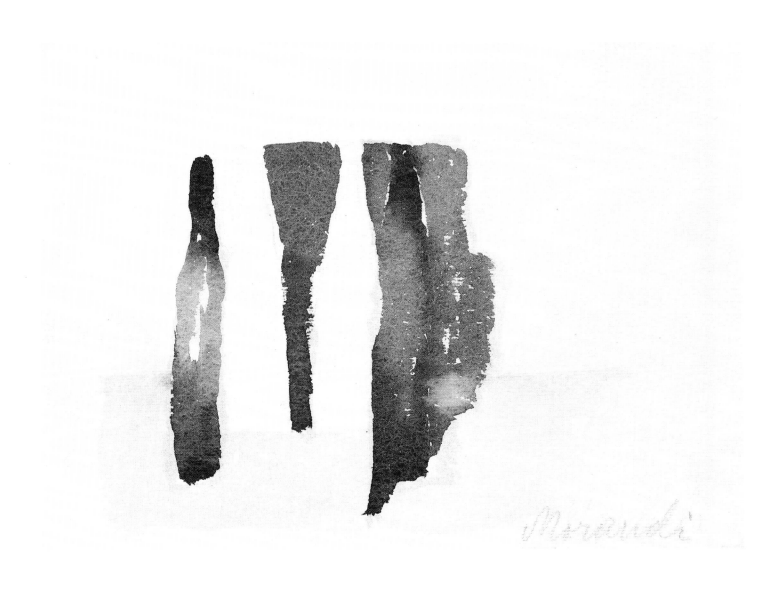

58 Still Life, 1959

59 Still Life, 1962

60 Still Life, 1962

61 Still Life, 1963

62 Still Life, 1961

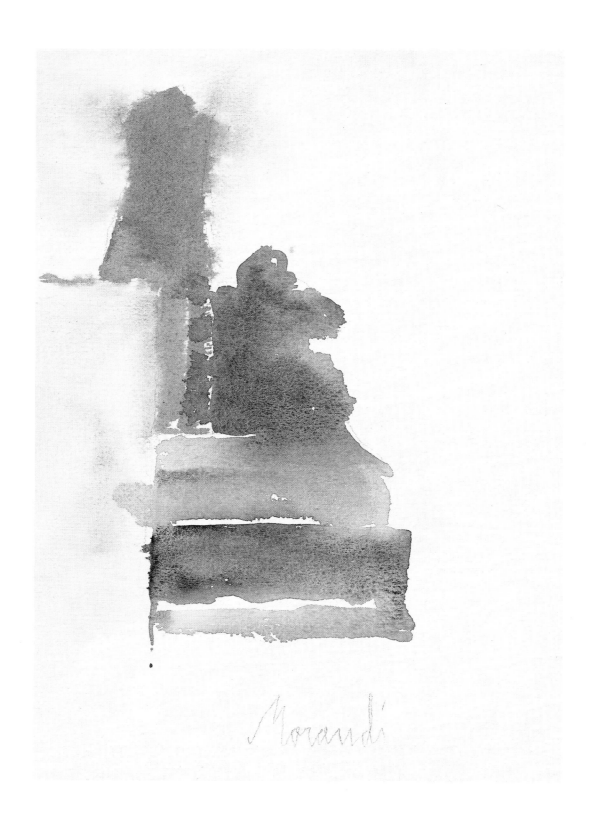

63 Still Life, 1963

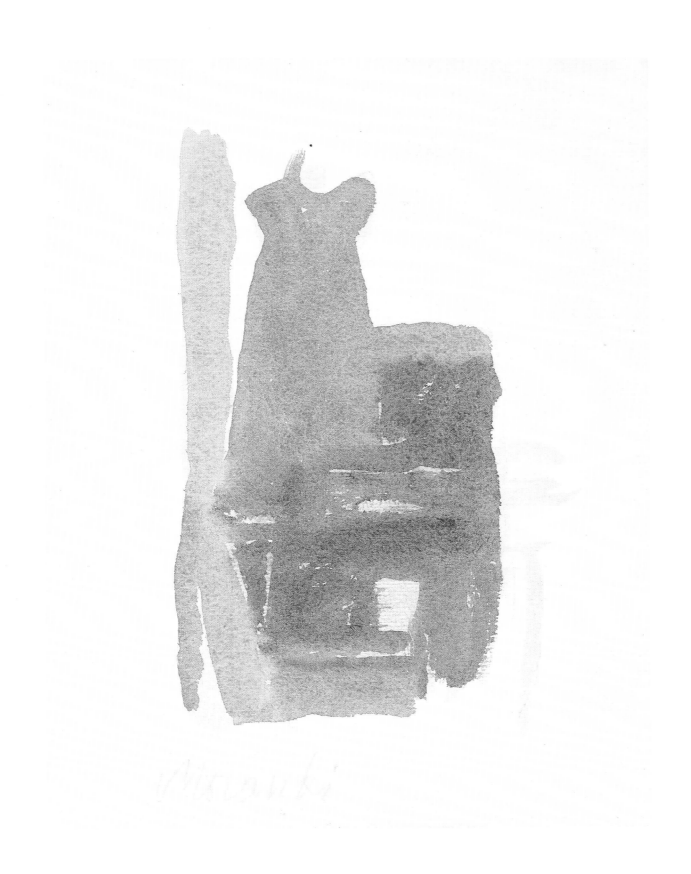

64 Still Life, 1963

Morandi as a Draughtsman

An artist can legitimately be called a draughtsman in the true sense of the word only if he succeeds in achieving authentic results when using the drawing medium. This requires that his drawings be something other than preliminary or preparatory studies for works in other media. There are, in fact, many examples of drawings by Morandi from the 1920s, thirties and forties that are studies for etchings or oil paintings. In the mid-fifties, however, their production gradually ceased. What is especially striking and completely unusual is that, once drawing overcame its subservient function in Morandi's art and its autonomy was thus emphasized, the number of his drawings increased enormously. Almost half of his total output of drawings dates from the sixties, the last four years of his life (in the almost three decades from 1912 to 1940 he had produced less than one eighth). The 1994 catalogue of his complete drawings describes 780 drawings; another 30 have turned up in the five years since, but the total is not likely to exceed 850 even in the distant future.

What does the achievement of these late drawings consist of? In no other medium did Morandi attain such a high degree of abstraction. His declared intent was to represent the structure of the reciprocal processes of dissolution of the object (which he always set up in front of himself in reality when he drew) and reconstruction of its form. The viewer experiences this interlocking, this flowing of one into the other, as one simultaneous process. Establishing the connection between the 'object as such' and the way viewing goes beyond or overcomes it is decisive. Conversely, what Morandi's manner of representation reveals cannot be found in the object itself, hence the relationship between original form and new form is only visible in the dissolution of the 'object as such.' The scope for reconstituting the object increases in proportion to the extent of its dissolution. Here Morandi's late work is at its most advanced.

Oil painting provided Morandi with means and possibilities that drawing does not possess: objects evaporate in an aura of light and colour; they dematerialize, when the background shines through them, such that not the form but the object itself is dissolved.

Because of its nature, drawing must make do with more limited possibilities. It only has line and the paper ground at its disposal. In this medium, Morandi attained his goal by fragmenting the objects and dissolving their contours. The absence of bold lines allows the background to penetrate the objects far more than in his oil paintings. This effect is a precondition for the creation of new forms. In dissolving the objects – by leaving out constitutive lines – Morandi sometimes went to such extremes that even the

experienced connoisseurs familiar with his repertoire of forms can no longer reconstruct the objects. At this point the drawings often manage to have surprising nonverbal explanatory powers with reference to each other (compare plates 92, 86 and 73–74). A remarkable 'conceptuality' can evolve from studying them. To preclude all misunderstanding, the point is of course not to recognize objects, but to experience through contemplation the antagonism between dissolution and reconstitution. This is the actual subject-matter of Morandi's drawings. At this point, at the latest, it becomes clear how obsolete the naturalist polemics against abstraction have become.

Another result of this advanced dissolution of the objects is that the spaces between the objects acquire meaning. The spaces themselves become objects; shadows appear as independent and equally valid elements of form.

Morandi was right-handed, but sometimes he deliberately drew with his left hand in order to give his line that strange vibration he deemed appropriate for expressing a doubting and doubtful perception of 'cosidetta realtà.' Thus he succeeded in making his late drawings – even more than his paintings and watercolours – into studies on the perceptibility of the world and of things.

The Drawings

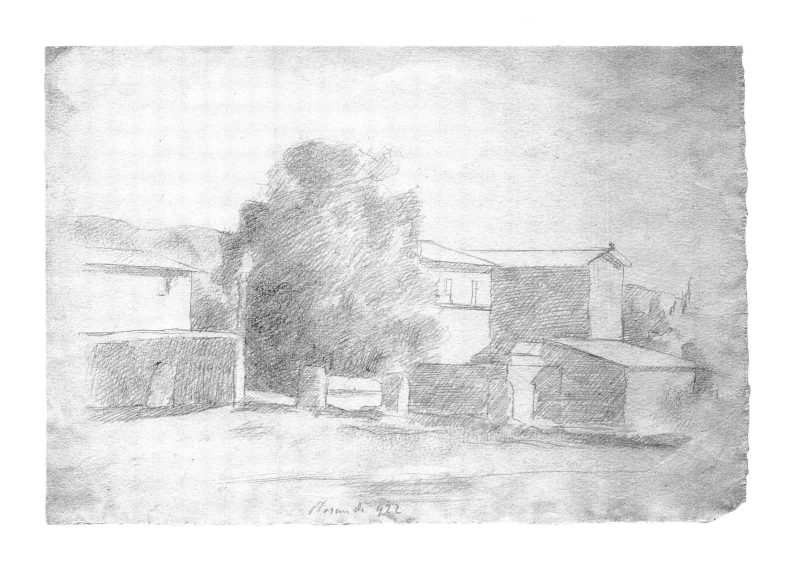

65 Landscape, 1922

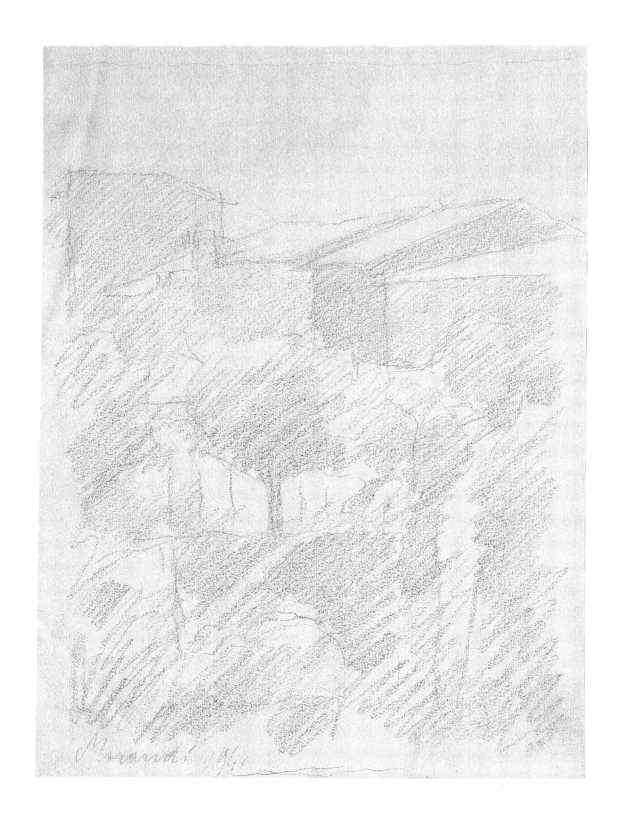

66 Landscape, 1941

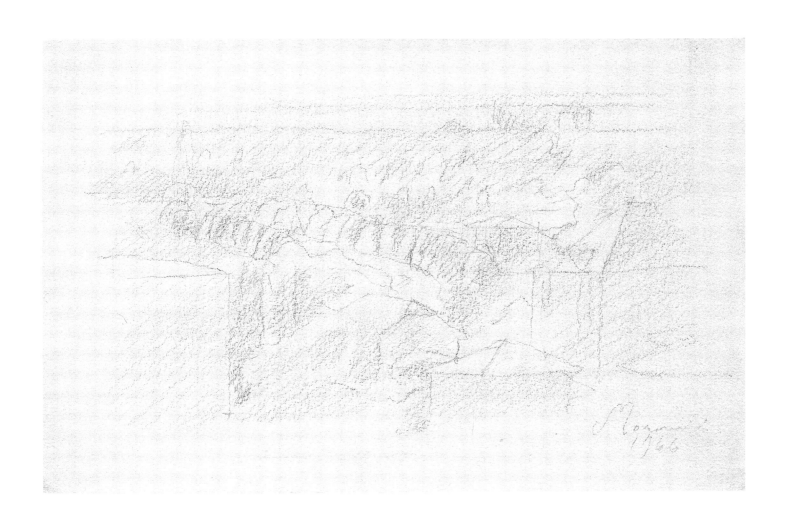

67 Landscape, 1946

68 Still Life, 1952

69 Still Life, 1956

70 Still Life, 1956

71 Still Life, 1956

72 Still Life, 1959

73 Still Life, 1959

74 Still Life, 1960

75 Still Life, 1960

76 Still Life, 1961

77 Still Life, 1961

78 Landscape, 1962

79 Landscape, 1962

80 Still Life, 1962

81 Still Life, 1962

82 Still Life, 1962

83 Still Life, 1962

84 Still Life, 1963

85 Still Life, 1963

86 Still Life, 1962

87 Still Life, 1962

88 Still Life, 1963

89 Still Life, 1963

90 Still Life, 1963

91 Still Life, 1963

92 Still Life, 1963

93 Still Life, 1963

Morandi as an Etcher

Etching is one of the classic print techniques. Giorgio Morandi devoted himself to this medium for about fifty years, and he is undoubtedly one of the outstanding painter-engravers, the great "peintre-graveurs," of European art.

Morandi's first attempts at etching date from 1911. He was taking an extension course in artistic design at the Accademia di Belle Arti in Bologna at the time. Although printing techniques were not taught, Morandi's curiosity to explore their potential was evidently so great that he taught himself the technique of etching on his own. He found guidance in the many printing manuals, of which the most famous also to cover the art of etching included Abraham de Bosse's *Traité des manières de graver en taille-douce etc.* dating from the 17th century and Adam von Bartsch's *Anleitung zur Kupferstichkunde* from the early 19th century. From Morandi himself we know that he obtained most of his information from a manual by the Bolognese painter Odoardo Fialetti, first published in 1660, and Vitalini's *L'incisione su metallo* issued in 1904. Because Morandi never had the academic training he had had for painting, he could hence be called a 'dilettante' in the field of etching. Nevertheless, the brilliance he soon attained in this technique earned him recognition from early on.

The artist's first work ever to be illustrated in a publication was the Cubist-influenced etching *Natura morta con bottiglie e brocca* (plate 98) dating from 1915. It was chosen by Giuseppe Raimondi to illustrate an article in the journal *La Raccolta* (no. 2, 1918). In the twenties Morandi's etchings were often published and shown at major exhibitions, such as the *Esposizione internazionale dell' incisione moderna* in 1927 in Florence and a year later at the 16th Biennale in Venice. The artist's growing recognition in specialist circles in the twenties eventually led to his being offered a professorship in etching at the Bologna Academy of Fine Arts in 1930. This honour was based solely on his distinguished international reputation, without his having participated in an application procedure. After years of teaching drawing in various primary schools, his mastery of etching provided him with academic status and financial security for the decades to come. Thus Morandi no longer had to depend only on the sale of his artwork for a living. In 1956 he retired from his professorship at his own request. The peak of public recognition for his print oeuvre during his lifetime was the First Prize for Graphic Art he was granted at the 2nd Biennale in São Paulo in 1953.

There is no doubt that etching ranks very highly in Morandi's artistic endeavour. He sees it as an independent artistic medium with unique expressive possibilities. It is never 'reproduction,' despite the fact that

connexions to motifs in his paintings can be found time and again. There are phases when his grappling with the etching technique is especially fruitful, and others when production is virtually nil and recedes completely behind painting. For the period between 1912 and 1920, Michele Cordaro's 1991 catalogue of Morandi's prints lists only 5 sheets. In the year 1921 alone, however, there are eleven. This productivity continues through the twenties and increases in the last years of the decade: in 1927 he creates fourteen plates, in 1928 also fourteen, and in 1929 there are as many as eighteen prints made from his plates. His graphic production declines gradually up to 1933, a year in which Morandi nevertheless etches nine prints. Then his preoccupation with printing dwindles entirely, and in the years up to 1961 he produces only twenty-one prints altogether. Even then, his work maintains a consistently high level until his last print, *Piccola natura morta con tre oggetti* (plate 109). It should be noted that as far as printing was concerned the artist concentrated almost exclusively on etching. Copperplate engravings are not listed at all in the catalogue, and there are only one woodcut and two drypoint etchings. Altogether Morandi created 136 prints.

Thematically Morandi's etchings revolve around the same motifs that are found in his oil paintings, drawings and watercolurs, i.e. mainly still lifes and landscapes in which there is never room for human figures. His earliest preserved etching dating from 1912, of which only a contemporary print is known, shows *Il ponte sul Savena a Bologna* (fig. 1). Even this view of a bridge in his home town seems strangely timeless. There is no human, no vehicle, no animal in sight. This fundamental feature of his art will become fully developed in the thirties. The actual localisation – even when a site is identifiable – the 'episodic' aspect of a landscape, is absolutely secondary to its purely physical conditions. No action takes place, there is only 'being there' and 'being such as it is.' For this reason the concept of time in the sense of succession plays no role in Morandi's works to begin with. Even when a group of houses appears to be lit by the morning sun, it seems unthinkable that the light could ever change in the course of the day. Current events are as if arrested, there is no temporal sequence of before and after. Time is immovable. It seems like a sibling, as it were, of the physical expansion of the space. The same phenomenon applies even more obviously to the artist's many still lifes, the arrangements of bottles, jugs, plates, bowls and tins that are most common in his etchings of his last creative decades. His reduction in the range of motifs and his concentration on a few pictorial ideas, always interpreted anew, testify to his tendency, or unexpressed aim, to linger in a kind of meditation, to attempt to extend the moment into infinity, and thus to come closer to its secret.

Formally the etchings deal with the same issues that Morandi was occupied with in his paintings and drawings all his life: the question of how to give convincing pictorial form to what one sees, and how to define the pictorial space where what is seen in real space is located and will remain. Further, he dealt with the role of light and dark in the appearance of objects, and finally, with the question of colours and their values. The latter may seem contradictory when it comes to etching, which is usually committed to being exclusively black and white.

Morandi tracks down the characteristics of the different artistic techniques in an ingenious way. In his drawings, it is abstract design that absorbs him increasingly. This is the art of leaving out and leaving blank, which in turn calls for the act of completing and perfecting through association. In his painting it is the flatly applied, material pigments with which he builds up the extremely subtle tonality of the pictures. In his etching, classed in his work somewhere between drawing and painting, he works with the black-and-white range and the pre-eminence of the line. As they

permit colour and tonality, they thus tend towards painting. Nevertheless, they never deny their origins in the abstract, 'drawn' line.

The intrinsic meaning of Morandi's etchings, their actual content, is inseparably linked to their formal design. In connexion with the above, this will become clearer upon closer inspection of the means used by the artist that are specific to etching. In the end, Morandi always revolves around the same complex of questions: what way of being is immanent to the objects that I see, that I contemplate as I look at them, in order to grasp them visually, as it were. How can I depict objects in a way that does justice to the dignity of their aura, that comes close to their essence? Morandi's aim in art to create works that are a 'responsive counterpart,' an 'evocative emblem' as Werner Haftmann put it, is the reflexion of his overriding approach to life. The view of art that this embodies testifies to what a gain there is in renunciation, and how rich frugality, how multifarious limitation and how colourful simplicity can be. We can sense Morandi's conviction that true events materialize in the renunciation of action. Withdrawal, moderation and humility in the face of the apparently 'dead' objects around us disclose their virulent vitality, power and effectualness. Thus we are able to apprehend exemplary truth and the structure of existence in them.

Morandi once said: "Nulla e più astratto del mondo visibile" – "Nothing is more abstract than the visible world."

His attitude seems especially convincing when we consider how Morandi deals with etching. The pictorial counterpart of the world he depicts there, the "metaphysics of ordinary objects," as Giorgio de Chirico once put it, which Morandi conjures up in his houses, trees, meadows, bouquets, shells, glasses and bottles, develops through the interaction of the partially abstract means and possibilities of the technique of etching, in other words, through its pictorial potential.

The principles of etching are based, briefly, on coating a metal plate with a layer of an acid-fast material, or acid-resist. The artist draws with an etching needle on the acid-resist, or etching ground, as with a pencil, but pressing firmly enough to expose the metal underneath. Morandi kept to common practice, but within its framework he experimented purposefully to achieve the best results. At first he used zink plates, in the twenties both zink and copper plates, and later only copper plates. The acid-resist he used corresponded to the traditional formulas: beeswax, blackish brown pigmented bitumen, with resin to harden it and to raise the melting point. Before drawing lines into this waxy layer with his etching needles, he blackened it with soot in order to obtain a greater contrast between the acid-resist and the underlying metal. Morandi owned etching needles of various thicknesses, including a needle with an angled oval point called "échoppe." Depending on the pressure applied, it allowed the etched line to be thickened or thinned, an effect which can usually only be obtained in copperplate engravings. His collection of tools also included a burin for deepening weakly etched lines, a drypoint needle, a scraper, a burnishing tool and his special instrument, a so-called "cat's tongue" ("lingua de gatto").

Once the plate is completed, it is immersed in an acid bath. The corrosive etching solution bites into the exposed metal and, depending on its concentration, digs the drawn lines into the metal. Morandi used nitric acid until 1927; later he preferred the so-called "Dutch bath" ("mordente olandese"), which is based on hydrochloric acid. It would be beyond the scope of this article to discuss the subtleties of complicated etching procedures, but Morandi thoroughly explored the effects of various acid concentrations and he continually printed trial proofs in the process. The "Dutch bath" permitted him to etch lines with clean contours, which were a basic prerequisite above all for the cross-hatching he applied with bravoura. Though the artist was satisfied with one application of acid as a rule, some etchings indicate that Morandi repeated the process up to three times (*Natura morta a grandi segni*, 1931, plate 101). He would then he stop out certain parts of the plate with varnish each time in order to protect them from the acid. In this way he obtained lines etched to different depths on the plate to produce various degrees of blackness in the print.

The technique of etching has slightly 'alchemistic' overtones, seeing as how its realisation is based on the use of acids and the effects of chemical processes. Despite the calculability, there is a certain degree of unpredictability and coincidence for the etcher when he exposes his plates to the acid bath. Incidentally, Morandi – as opposed to his great example Rembrandt van Rijn – did not strive to print several different stages of one print, or various "states" of a plate, but prepared one valid state only.

After the acid-resist is removed from the plate, it is inked with printing ink and wiped clean. The ink remaining in the incised lines is 'drawn up' into the paper placed on the plate under the pressure of the printing press. The plate must be re-inked for every print. Around two hundred prints are possible without wearing off the plate and causing a reduction in quality. For Morandi himself usually a few prints sufficed. He printed them at the Academy of Art himself or at home with his own press. It was not until the thirties that larger editions beyond that were published by the Calcografia Nazionale in Rome.

The fascinating effect, the almost 'magical' charisma even, of Morandi's etchings is essentially based on three means of pictorial design: the line, the tone of the plate and the paper. It is important to keep this in mind because Morandi's prints demonstrate how fundamentally the pictorial content is linked to artistic and technical methods. Not only the motif, its isolation or combination, its location in space, and the perspective in which it is shown create the image of the world the artist sees around him for his audience. Morandi's artistic interpretations make the convincing impression that they are as 'true' as what they depict. His 'pictures' virtually capture a facet of constantly changing reality and are released from the progress of time. This convincing power intrinsic to his pictures is based essentially on the interaction of abstract pictorial means. They suggest that Morandi's etched pictures are objectifications, removed from the emotional and intellectual 'partiality' of their creator.

This becomes especially clear when we look at the basic means used to create form in every etching: the line. The print specialist Hans Wolfgang Singer even called the etched line the only real, genuine, even line, as the line "par excellence." In fact, the charm of the etched line lies on the one hand in a mixture of spontaneity and subjectivity, on the other in exactitude, mechanical uniformity and anonymity. In one respect it is based on the direct stroke of the artist, bears his personal impulsiveness, as it were, in flourishes, curlicues, hooklets, knife-sharp straight lines, curves, and hatches. The stroke of the line in etching almost has the freedom of a pencil-drawn line. However, the etched line loses its immediacy because the strength and firmness or hesitancy and softness of the active hand are removed, neutralized and thus mediated by the subsequent process of etching.

It is revealing that from the start Morandi builds up his entire system of strokes on the most abstract form of line: the straight line, short or long. Lines forming contours and individual shapes are remarkably rare, and when Morandi uses them to outline a jug or the crown of a tree they are never closed or dominant. They retreat completely behind an anonymous system of parallel strokes and cross-hatching. An individual line only acquires its meaning as something that creates form when it is in combination with others. It's easy to understand why, according to Morandi, there is "nothing more abstract than the world around us" when you take the time to look closely at each etching one by one: sky, earth, stones, flowers, shells, houses – Morandi's entire pictorial world – materialize through an abstract, ordering, regular-looking network of lines. Morandi's mastery, however,

never lets the impression of a boring schematism arise. Of course many nuances and variations can be found in the quality of the individual linear strokes, yet the 'amplitude' of each plate is strictly defined. This produces an impression of clarity, calm and balance, and evokes the element of timelessness mentioned above. Each etching has its own carefully weighed rhythm, unmistakable 'timbre,' characteristic play of light and dark, 'colour,' sense of space, and texture. This comes about essentially through the network of lines, disciplined and subjected to an ordering creative will.

A second stilistic means is the plate tone that frequently shows in Morandi's etchings. It comes about by deliberately leaving, or not completely wiping off, the printing ink left on the flat parts of the plate before printing. Subordinated to the network of lines, the plate tone serves Morandi above all to increase atmospheric impressions and modulate effects of light and shade, sometimes even to simulate a kind of 'inner' frame (*Natura morta di vasi, bottiglie ecc. su un tavolo*, around 1929; *Natura morte con la tazzina bianca a sinistra*, 1930, plate 97). With the help of this artistic device Morandi distances the viewer visually in a barely noticable way and underscores the objectification intended.

The third and subtly applied stilistic means of the artist is the paper he prints on. Morandi preferred handmade vat paper in ivory, chamois and grey shades and of various weights. He occasionally achieves special effects by using layered papers. In *Il poggio di sera* the gentle, warm atmosphere corresponding to twilight results not least from the thin, lightly toned China paper pressed onto heavier handmade paper. The harsher white of rag paper, on the other hand, responds to the cooler morning atmosphere of *Il poggio al mattino*.

Of course Morandi's etchings, these sensations of the unspectacular, demand much more intense examination than this text permits. In their timeless serenity, as all Morandi's works do, they give the viewer the opportunity for meditative contemplation, sublimating reflection. They appear like a silent corrective in our noisy world. They counter its endless onslaught of visual effects with the eloquence of a pause.

The Etchings

94　Landscape, 1927

95 Hilly Landscape, 1927

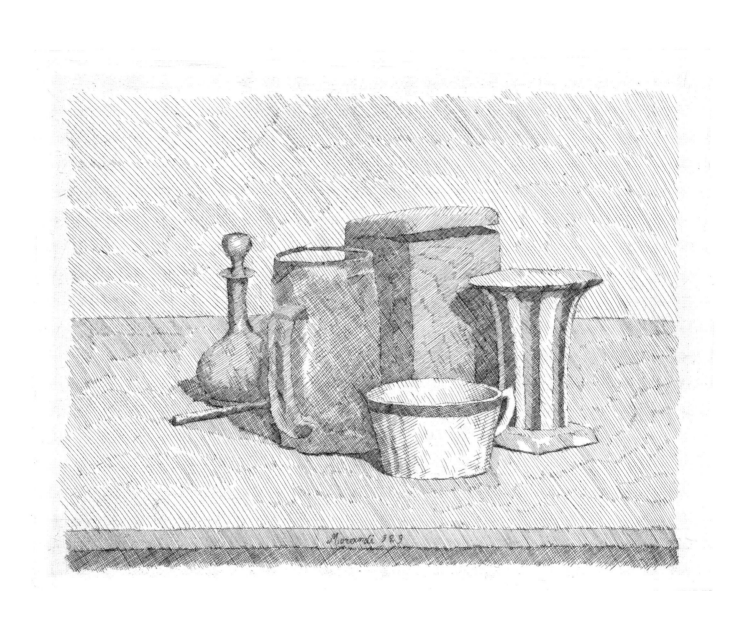

96 Still Life with Small Cup and Carafe, 1929

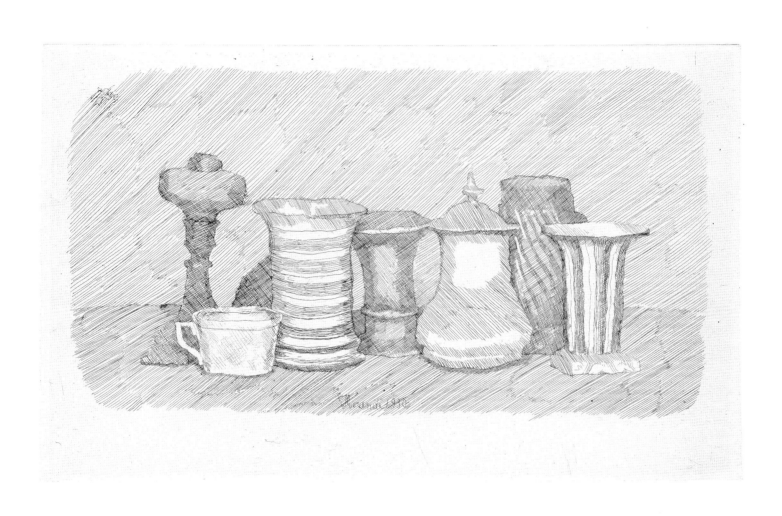

97 Still Life with Small White Cup on the Left, 1930

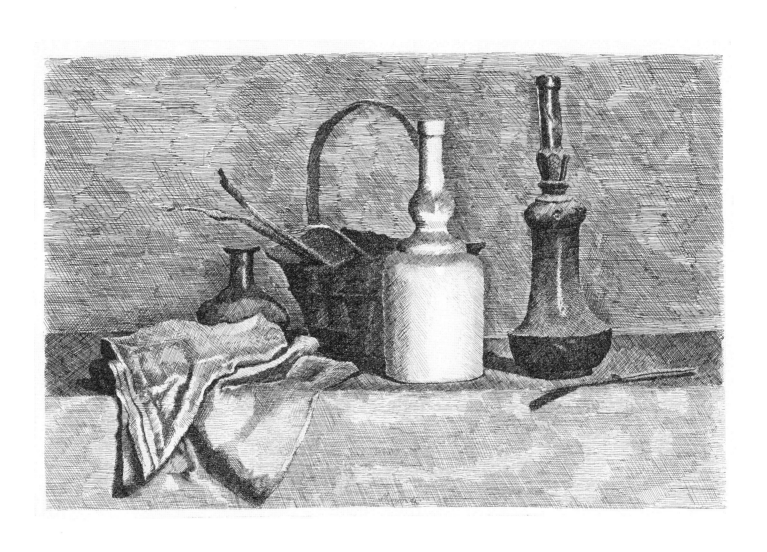

98 Still Life with Drapery on the Left, 1927

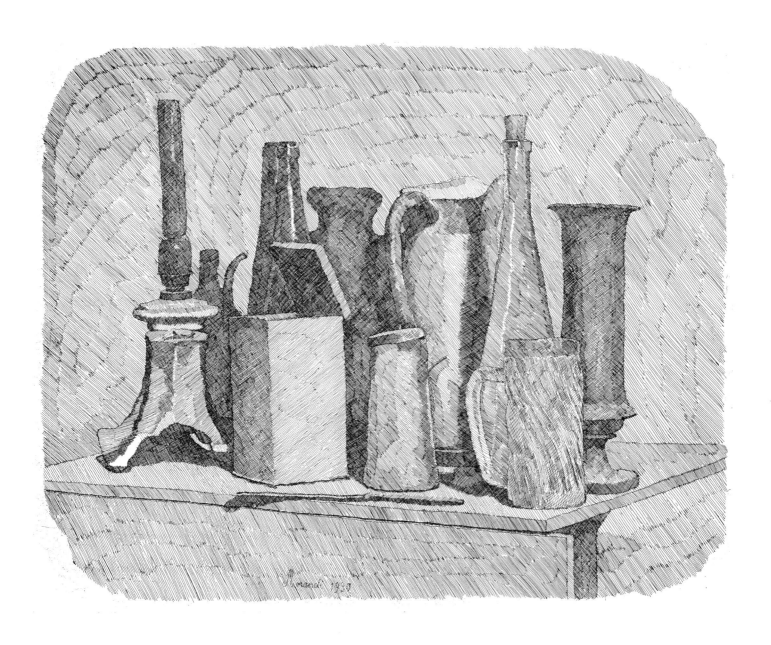

99 Large Still Life with Petroleum Lamp, 1930

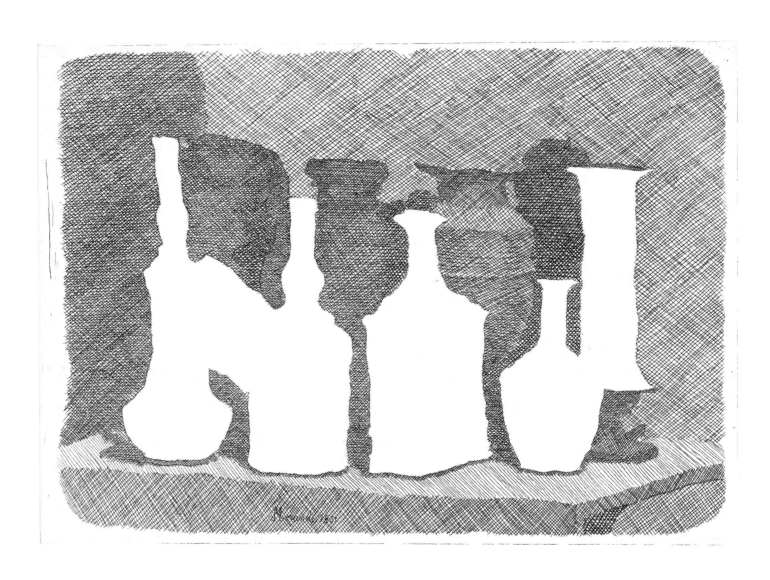

100 Still Life with Vases on a Table, 1931

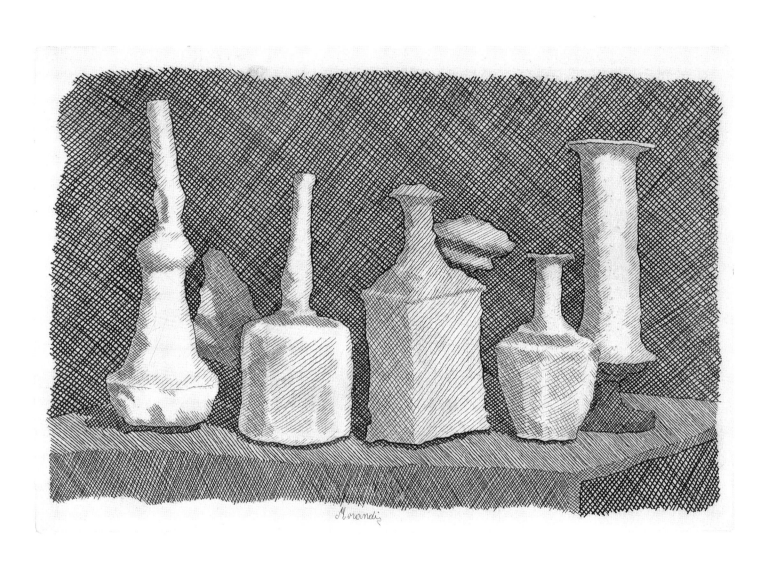

101 Still Life with Bold Lines, 1931

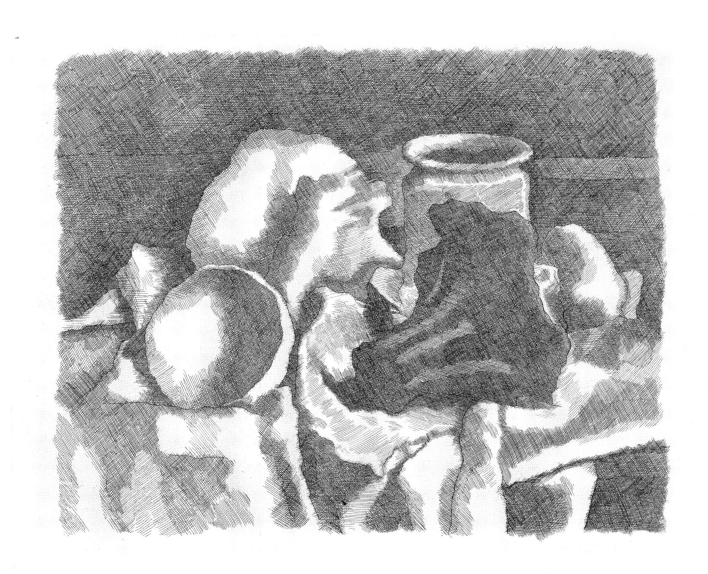

102 Still Life with Drapery, 1931

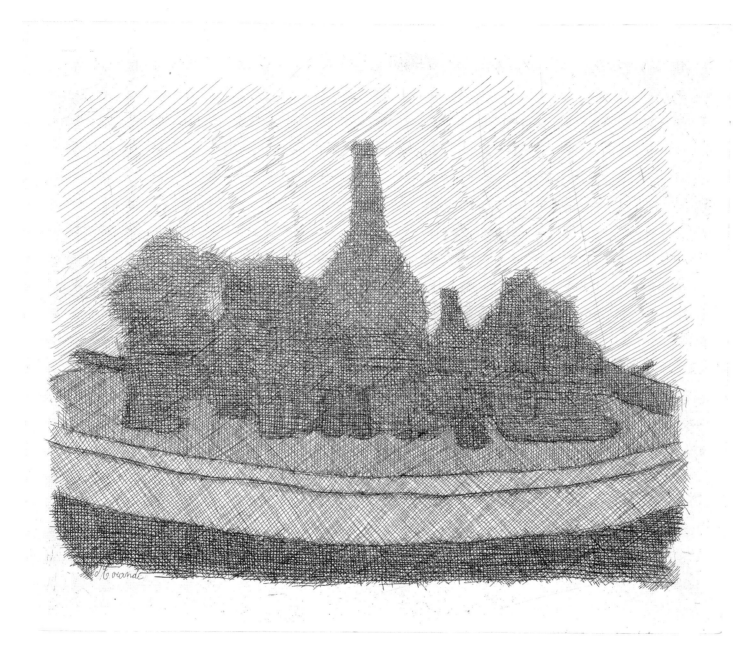

103 Still Life, 1931

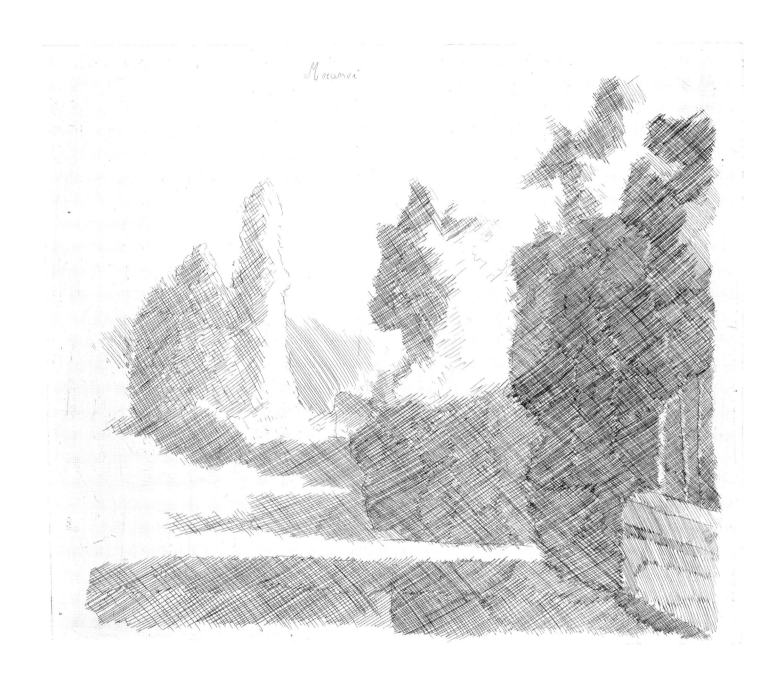

104 Landscape, c. 1930

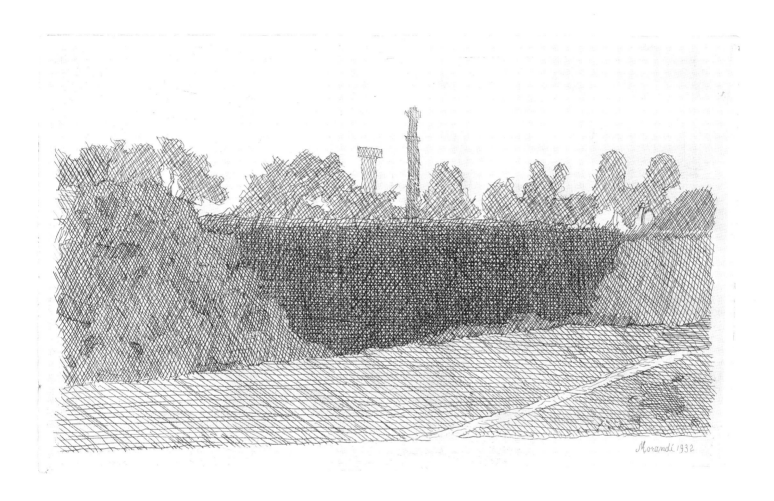

105 Landscape, 1932

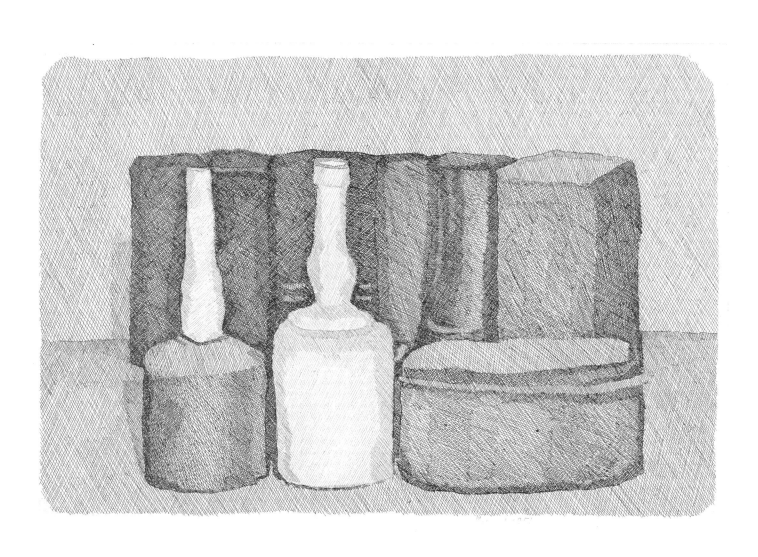

106 Still Life with Nine Objects, 1954

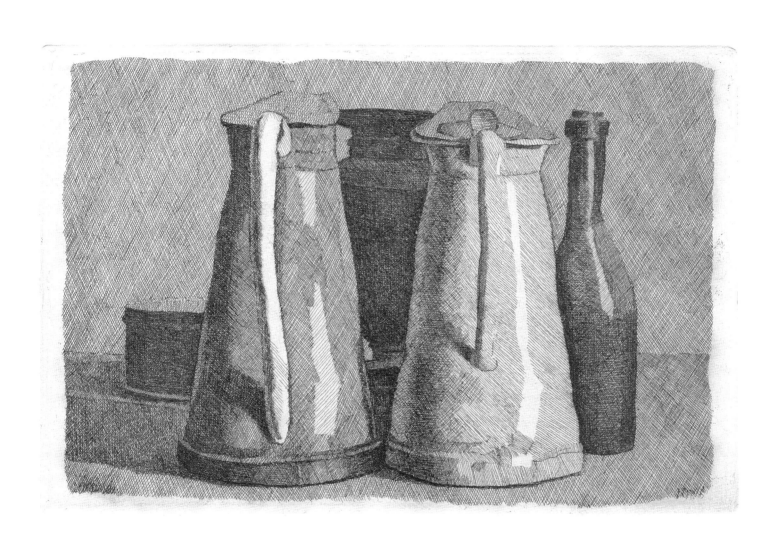

107 Still Life with Five Objects, 1956

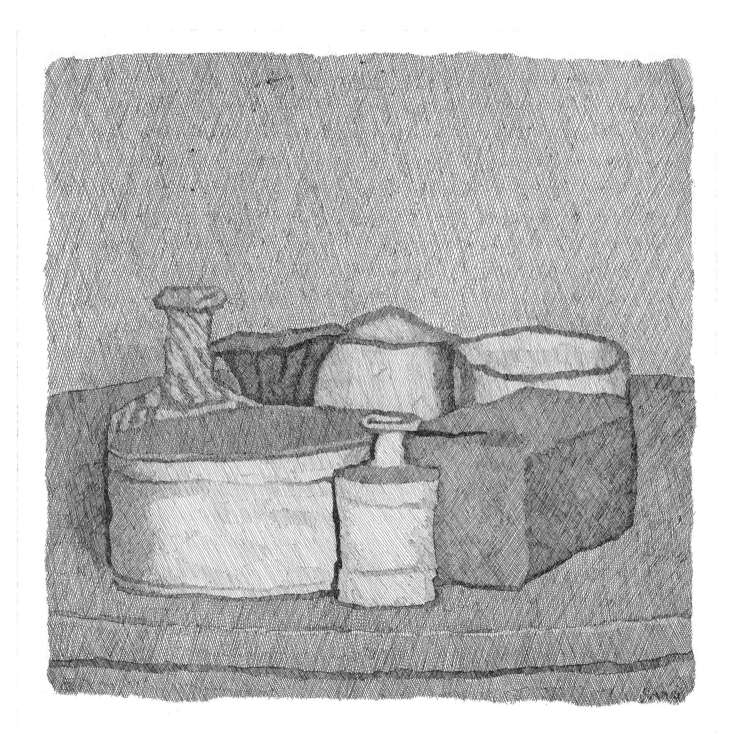

108 Still Life with Four Objects and Three Bottles, 1956

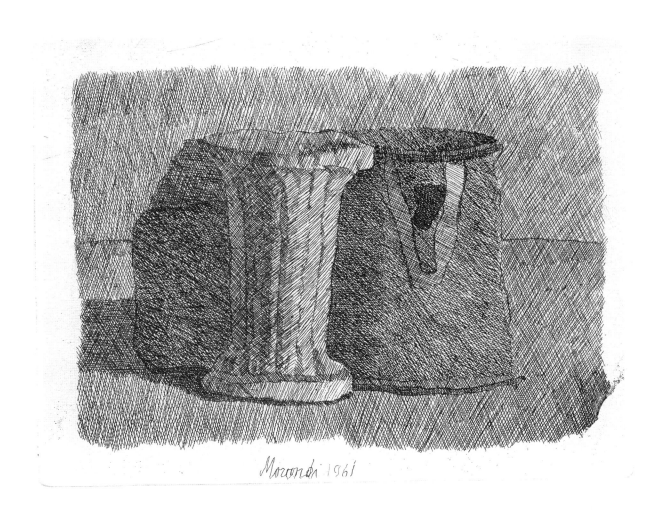

Morandi 1961

109 Small Still Life with Three Objects, 1961

List of Illustrations

15
Still life, 1958
Oil on canvas, 35.5 × 40.6 cm
Signed lower left: Morandi
V. 1088
Freiburg im Breisgau, Morat-Institut für Kunst und
Kunstwissenschaft
Exhibitions: Munich 1981
Reproduced in: Morat 1979, p. 21

16
Still life, c. 1957
Oil on canvas, 25.5. × 40.5 cm
Signed lower left: Morandi
V. 1068
Iowa City, The University of Iowa Museum of Art
Exhibitions: San Francisco, New York, Des Moines
1981/82

17
Still life, 1960
Oil on canvas, 30 × 40 cm
Signed lower left: Morandi
V. 1171
Modena, private collection
Exhibitions: Ferrara 1978 – Munich 1981 – Madrid,
Barcelona 1984/85 – Marseille 1985 – Tübingen,
Düsseldorf 1989/90 – Bologna 1990 – Saarbrücken,
Dresden 1993 – Klagenfurt, Ljubljana 1996/97

18
Still life, 1960
Oil on canvas, 30.6 × 35.6 cm
Signed and dated on the back: Morandi 1960
V. 1181
Private collection
Exhibitions: Geneva 1977/78 – Munich 1981 –
Nijmegen 1982 – Innsbruck 1982 – Saarbrücken,
Dresden 1993
Reproduced in: Vitali 1964/65/70, pl. 247 –
Jouvet/Schmied 1982, ill. 77

19
Still life, 1960
Oil on canvas, 35.7 × 40.9 cm
Signed lower right: Morandi
V. 1187
Private collection
Exhibitions: Saarbrücken, Dresden 1993

20
Still life, 1963
Oil on canvas, 30 × 35 cm
V. 1308
Zumikon (Zurich), Max Bill Collection
Exhibitions: Saarbrücken, Dresden 1993

21
Still life, 1960
Oil on canvas, 30.5 × 40.5 cm
Dated on the back: 1960
V. 1197
Bologna, Museo Morandi
Exhibitions: Ferrara 1978 – Munich 1981 – Madrid,
Barcelona 1984/85 – Marseille 1985 – Bologna 1990 –
Bologna 1993 – Saarbrücken, Dresden 1993

22
Still life, 1962
Oil on canvas, 34 × 39 cm
Signed on the back: Morandi
V. 1262
Verona, Galleria dello Scudo
Exhibitions: Frankfurt on the Main 1978 – Munich 1981
– Nijmegen 1982 – Innsbruck 1982 – Saarbrücken,
Dresden 1993

23
Landscape, 1961
Oil on canvas, 35 × 40 cm
Signed on the back: Morandi
V.1248
Winterthur, Kunstmuseum
Exhibitions: Bern 1965 – Bologna 1966 – London
1970/71 – Paris 1971 – Milano 1971 – Munich 1981 – San
Francisco, New York, Des Moines 1981/82 – Tübingen,
Düsseldorf 1989/90 – Saarbrücken, Dresden 1993

24
Landscape, 1961
Oil on canvas, 41 × 36 cm
Signed on the back: Morandi
V.1252
Albinea (Reggio Emilia), Achille e Ida Maramotti
Collection
Exhibitions: Bern 1965 – Venice 1966 – Bologna 1966 –
Milano 1971 – Rome 1973 – Geneva 1978/79 – Munich
1981 – San Francisco, New York, Des Moines 1981/82 –
Nijmegen 1982 – Innsbruck 1982 – Tübingen, Düssel-
dorf 1989/90 – Bologna 1990 – Saarbrücken, Dresden
1993
Reproduced in: Giuffré 1970, ill. 34 – Morat 1979, colour
reproduction p. 23 – Jouvet/Schmied 1982, ill. 85 –
Pasini 1989, ill. 73

25
Still life, 1962
Oil on canvas, 35 × 35 cm
Signed below centre: Morandi
V.1280
Bologna, Museo Morandi
Exhibitions: Ferrara 1978 – Bologna 1990 – Saarbrücken,
Dresden 1993 – Bologna 1993

26
Still life, 1962
Oil on canvas, 36 × 36 cm
Signed lower left: Morandi
V.1284
Private collection
Exhibitions: Geneva 1968 – St Petersburg, Moscow 1973
– Munich 1981 – Nijmegen 1982 – Innsbruck 1982 –
Saarbrücken, Dresden 1993
Reproduced in: Morat 1979, p. 25
(colour reproduction) – Jouvet/Schmied 1982, ill. 81

27
Still life, 1962
Oil on canvas, 27 × 32.5 cm
Signed lower left: Morandi
V.1285
Siegen, Siegerlandmuseum im Oberen Schloß
Exhibitions: Munich 1981 – Madrid, Barcelona 1984/85
– Tübingen, Düsseldorf 1989/90 – Bologna 1990 – Saar-
brücken, Dresden 1993

28
Still life, 1962
Oil on canvas, 25.7 × 30.7 cm
Signed lower left: Morandi
V.1281
Carpi (Modena), Fondazione Uberto Severi
Exhibitions: Saarbrücken, Dresden 1993

29
Still life, 1962
Oil on canvas, 30 × 30 cm
Signed lower left: Morandi
V.1273
Edinburgh, Scottish National Gallery of Modern Art
Exhibitions: – London 1970/71 – Paris 1971 – Tübingen,
Düsseldorf 1989/90 – Bologna 1990 – Saarbrücken,
Dresden 1993

30
Still life, 1962
Oil on canvas, 30.6 × 30.6 cm
Signed on the back: Morandi
V.1272
Albinea (Reggio Emilia), Achille e Ida Maramotti
Collection
Exhibitions: Brussels 1992 – Saarbrücken, Dresden 1993
– Verona, Venice 1997/98
Reproduced in: Vitali 1965/70, pl. 256 – Morat 1984,
color pl. V, p.11

31
Landscape, 1962
Oil on canvas, 50 × 50 cm
V.1287
Bologna, Museo Morandi
Exhibitions: Ferrara 1978 – Munich 1981 – Bologna 1990
– Brussels 1992 – Saarbrücken, Dresden 1993 –
Bologna 1993
Reproduced in: Vitali 1964/65/70, no. 257

32
Landscape, 1962
Oil on canvas, 40 × 40 cm
Signed on the back: Morandi
V.1289
Paris, Paola Ghiringhelli Collection
Exhibitions: Tübingen, Düsseldorf 1989/90 –
Bologna 1990 – Saarbrücken, Dresden 1993
Reproduced in: Vitali 1964/65/70, no. 258

33
Still life, 1963
Oil on canvas, 20 × 30 cm
Signed lower left: Morandi
V.1298
New York, Herman C. Goldsmith Collection
Exhibitions: Saarbrücken, Dresden 1993
Reproduced in: Morat 1984, no. 22, pl. VI, p. 13

34
Still life, 1963
Oil on canvas, 20.5 × 35.5 cm
Signed lower right: Morandi
V.1300
Bologna, private collection
Exhibitions: Tübingen, Düsseldorf 1989/90 –
Bologna 1990 – Saarbrücken, Dresden 1993 –
Schleswig 1998

35
Still life, 1963
Oil on canvas, 25 × 30 cm
Signed below centre: Morandi
V.1309
Basel, private collection
Exhibitions: Munich 1981 – Saarbrücken, Dresden 1993

36
Still life, 1964
Oil on canvas, 25.7 × 30.5 cm
Signed lower right: Morandi
V.1343
Albinea (Reggio Emilia), Achille e Ida Maramotti
Collection
Exhibitions: Saarbrücken, Dresden 1993
Reproduced in: Vitali 1965/70, pl. 262 – Basile 1982,
p. 72

37
Still life, 1963
Oil on canvas, 30 × 30 cm
Signed lower left: Morandi
V.1310
Frankfurt on the Main, private collection
Exhibitions: Saarbrücken, Dresden 1993

38
Still life, 1964
Oil on canvas, 20.5 × 30.5 cm
Signed lower left: Morandi
V.1343
Bologna, Museo Morandi
Exhibitions: Bern 1965 – Bologna 1966 – Milano 1971 –
Ferrara 1978 – Munich, 1981 – Madrid, Barcelona
1984/85 – Marseille 1985 – Tübingen, Düsseldorf
1989/90 – Bologna 1990 – Saarbrücken, Dresden 1993 –
Bologna 1993
Reproduced in: Vitali 1964/65/70, no. 264

39
Still life, 1963
Oil on canvas, 30 × 35 cm
Signed lower left: Morandi
V.1323
Bologna, Museo Morandi
Exhibitions: – Bern 1965 – Bologna 1966 – London
1970/71 – Paris 1971 – Milano 1971 – St Petersburg,
Moscow 1973 – Munich 1981 – San Francisco, New York,
Des Moines 1981/82 – Madrid, Barcelona 1984/85 –
Marseille 1985 – Tübingen, Düsseldorf 1989/90 –
Bologna 1990 – Saarbrücken, Dresden 1993 – Bologna
1993 – Verona, Venice 1997/98
Reproduced in: Vitali 1964/65/70; no. 260

40
Still life, 1963
Oil on canvas, 25 × 30 cm
Signed lower left: Morandi
V.1324
Paris, Paola Ghiringhelli Collection
Exhibitions: Milano 1970/71 – Madrid, Barcelona
1984/85 – Marseille 1985 – Bologna 1990 – Saar-
brücken, Dresden 1993 – Verona / Venice 1997/98
Reproduced in: Vitali 64/65/70, no. 255

41
Still life, 1963
Oil on canvas, 25.2 × 30.8 cm
Signed lower left: Morandi
V.1312
Private collection
Exhibitions: Brussels 1992

42
Still life, 1963
Oil on canvas, 25 × 30 cm
V.1313
Geneva, private collection
Exhibitions: Munich 1981 – Saarbrücken, Dresden 1993

43
Still life, 1963
Oil on canvas, 30.5 × 30.5 cm
Signed lower left: Morandi
V.1307
Venice, private collection
Exhibitions: Verona, Venice 1997/98

44
Still life, 1964
Oil on canvas, 30 × 30 cm
V.1340
Rome, private collection
Exhibitions: Tübingen, Düsseldorf 1989/90 – Bologna
1990 – Brussels 1992 – Saarbrücken, Dresden 1993 –
Verona, Venice 1997/98
Reproduced in: Vitali 64/65/70, pl. 263

45
Landscape, 1961
Oil on canvas, 30.5 × 30.5 cm
V.1251
Bologna, Museo Morandi

46
Landscape, 1963
Oil on canvas, 40 × 45 cm
Signed below centre: Morandi
V.1331
Exhibitions: San Francisco, New York, Des Moines
1981/82 – Brussels 1992
Reproduced in: Morat 1984, color pl. VIII, p. 17

Watercolours

47
Landscape, 1963
Watercolour on coarse-grained handmade
Fabriano paper, 24.3 × 31.9 cm
Signed below centre: Morandi
Stamp of the Galleria del Milione, Milan,
on the verso: 7351
P.1963 32
Private collection
Exhibitions: Bologna 1990/91 – Saarbrücken, Dresden
1993 – Vienna, Rotterdam 1995

48
Still life, 1956
Watercolour on coarse-grained handmade
Fabriano paper, 16.1 × 24.1 cm
Signed below centre: Morandi
Stamp of the Galleria del Milione, Milan,
on the verso: 7540/1
P.1956 7
Private collection
Exhibitions: Munich 1981 – Nijmegen 1982 – Innsbruck
1982 – Bologna 1990/91 – Saarbrücken, Dresden 1993 –
Vienna, Rotterdam 1995
Reproduced in: Morat 1979, p. 29 – Jouvet/Schmied
1982, no. 59

49
Landscape, 1957
Watercolour on coarse-grained handmade
Fabriano paper, 23.2 × 31.2 cm
Signed lower right: Morandi
Stamp of the Galleria del Milione, Milan,
on the verso: 7812
P.1957 17
Private collection
Exhibitions: Saarbrücken, Dresden 1993
Reproduced in: Morat 1984, color pl. IX, p. 19

50
Landscape, 1958
Watercolour on coarse-grained handmade
Fabriano paper, 32 × 18.8 cm
Signed below centre: Morandi

Stamp of the Galleria del Milione, Milan,
on the verso: 7733
P.1958 32
Bologna, private collection
Exhibitions: Bologna 1990/91 – Saarbrücken, Dresden
1993 – Vienna, Rotterdam 1995 – Klagenfurt, Ljubljana
1996/97

51
Landscape, 1957
Watercolour on coarse-grained handmade
Fabriano paper, 25 × 34.1 cm
Signed and dated below centre: Morandi 1957;
signed and dated on the verso in red ball point
pen by the artist: Morandi, 1957
P.1957 8
Private collection
Exhibitions: Munich 1981
San Francisco, New York, Des Moines 1981/82 –
Nijmegen 1982 – Innsbruck 1982 – Saarbrücken, Dres-
den 1993

52
Landscape (ruins of the Second World War
in Grizzana), 1958
La casa diroccata
Watercolour on coarse-grained handmade
Fabriano paper, 24.6 × 21.2 cm
Signed below centre: Morandi
Stamp of the Galleria del Milione, Milan,
on the verso: 7888/6
P.1958 15
Private collection
Exhibitions: Munich 1981 – San Francisco, New York,
Des Moines 1981/82 – Nijmegen 1982 – Innsbruck 1982
– Saarbrücken, Dresden 1993

53
Still life, 1958
Watercolour on coarse-grained handmade
Fabriano paper, 19.2 × 25 cm
Signed below centre: Morandi
Stamp of the Galleria del Milione, Milan,
on the verso: 121 71/a
P.1958 33 (in the supplement to the catalogue
of the complete watercolours)
Freiburg im Breisgau, Morat-Institut für Kunst und
Kunstwissenschaft
Exhibitions: Saarbrücken, Dresden 1993

54
Still life, 1959
Watercolour on coarse-grained handmade
Fabriano paper, 21.3 × 31.5 cm
Signed below centre: Morandi
P.1959 10
Private collection
Exhibitions: Munich 1981 – San Francisco, New York,
Des Moines 1981/82 – Saarbrücken, Dresden 1993 –
Vienna, Rotterdam 1995
Reproduced in: Morat 1979, no. 18, ill. p. 31

55
Still life, 1959
Watercolour on coarse-grained handmade
Fabriano paper, 24.4 × 33.3 cm
Signed and dated lower left: Morandi 1959
P.1959 14
Private collection
Exhibitions: Saarbrücken, Dresden 1993 – Vienna,
Rotterdam 1995

56
Still life, 1959
Watercolour on coarse-grained handmade
Fabriano paper, 16.1 × 19.8 cm (here reproduced
in original size)
Signed below centre: Morandi
P.1959 30
Private collection
Exhibitions: Munich 1981 – Saarbrücken, Dresden 1993

57
Still life, 1959
Watercolour on smooth handmade paper,
20.2 × 23.4 cm
Signed below centre: Morandi
Stamp of the Galleria del Milione, Milan,
on the verso: 7705
P.1959 33
Private collection
Exhibitions: Saarbrücken, Dresden 1993

58
Still life, 1959
Watercolour on coarse-grained handmade
Fabriano paper, 16.1 × 20.8 cm
Signed lower right: Morandi
Inscribed by the artist on the verso: Signor
Gordon (= John Gordon, Palm Beach,
previous owner of the watercolour)
P.1959 39
Private collection
Exhibitions: Munich 1981 – Nijmegen 1982 – Innsbruck
1982 – Bologna 1990/91 – Saarbrücken, Dresden 1993 –
Vienna, Rotterdam 1995

59
Still life, 1962
Watercolour on coarse-grained handmade
Fabriano paper, 22.5 × 13.8 cm
Signed below centre: Morandi
Stamp of the Galleria del Milione, Milan,
on the verso: 7643
P.1962 22
Private collection
Exhibitions: Saarbrücken, Dresden 1993 – Vienna,
Rotterdam 1995
Reproduced in: Morat 1984, no. 33, pl. X, p. 21 –
Quaderni Morandiani 1985, p. 110 – Sidney 1997, p. 22

60
Still life, 1962
Watercolour on coarse-grained handmade
Fabriano paper, 20 × 24.4 cm
Signed below centre: Morandi
Stamp of the Galleria del Milione, Milan,
on the verso: 8036
P.1962 23
Private collection
Exhibitions: Saarbrücken, Dresden 1993

61
Still life, 1963
Watercolour on coarse-grained handmade
Fabriano paper, 17.5 × 25.4 cm
Signed lower left: Morandi
Stamp of the Galleria del Milione, Milan,
on the verso: 7804
P.1963 16
Private collection
Exhibitions: Saarbrücken, Dresden 1993
Reproduced in: Morat 1984, no. 34

62
Still life, 1961
Watercolour on coarse-grained handmade
Fabriano paper, 21.1 × 16.2 cm (here reproduced
in original size)
Signed lower left: Morandi
Stamp of the Galleria del Milione, Milan,
on the verso: 9124
P.1961 1
Private collection
Exhibitions: Munich 1981 – San Francisco, New York,
Des Moines 1981/82 – Saarbrücken, Dresden 1993
Reproduced in: Morat 1979, colour reproduction p. 33
Basile 1982, p. 65

63
Still life, 1963
Watercolour on coarse-grained handmade
Fabriano paper, 26.8 × 18.9 cm
Signed below centre: Morandi
Stamp of the Galleria del Milione, Milan,
on the verso: 7561
P.1963 3
Private collection
Exhibitions: Saarbrücken, Dresden 1993 – Vienna,
Rotterdam 1995 – Paris 1996/97

64
Still life, 1963
Watercolour on coarse-grained handmade
Fabriano paper, 21.1 × 16.2 cm (here reproduced
in original size)
Signed lower left: Morandi
P.1963 4
Munich, Staatliche Graphische Sammlung
Exhibitions: Bologna 1990/91 – Saarbrücken,
Dresden 1993

Drawings

65
Landscape (the courtyard), 1922
Il Cortile
Pencil, 21.9 × 31 cm
Signed and dated below centre: Morandi 922
T.16 P.1922 1
Munich, private collection
Exhibitions: Bologna 1966 – Ferrara 1978 – Munich 1981
– San Francisco, New York, Des Moines 1981/82 – Nij-
megen 1982 – Innsbruck 1982 – Saarbrücken, Dresden
1993
Reproduced in: Neri Pozza 1976, pl. 12 – Morat 1979,
p. 33

66
Landscape (courtyard in Via Fondazza), 1941
Cortile di Via Fondazza
Pencil, 29.2 × 21.2 cm
Signed and dated lower left: Morandi 1941
T.61 P.1941 13
Freiburg im Breisgau, Morat-Institut für Kunst und
Kunstwissenschaft
Exhibitions: Munich 1981 – Nijmegen 1982 – Innsbruck
1982 – Saarbrücken, Dresden 1993
Reproduced in: Morat 1979, p. 37

67
Landscape, 1946
Pencil, 16.1 × 24.1 cm
Signed and dated lower right: Morandi 1946
T.84 P.1946 14
Freiburg im Breisgau, Morat-Institut für Kunst und
Kunstwissenschaft
Exhibitions: Saarbrücken, Dresden 1993

68
Still life, 1952
Pencil, 16.7 × 24.2 cm
T.398 P.1952 9
Freiburg im Breisgau, Morat-Institut für Kunst und
Kunstwissenschaft
Exhibitions: Saarbrücken, Dresden 1993
Reproduced in: Morat 1984, p. 6

69
Still life, 1956
Pencil, 17.9 × 20.7 cm
Signed below centre: Morandi
Not listed in Tavoni
P.1956 19
Freiburg im Breisgau, Morat-Institut für Kunst und
Kunstwissenschaft
Exhibitions: Saarbrücken, Dresden 1993

70
Still life, 1956
Pencil, 24 × 33.3 cm
Signed and dated lower right: Morandi 1956
T.159 A P.1956 28
Freiburg im Breisgau, Morat-Institut für Kunst und
Kunstwissenschaft
Exhibitions: Saarbrücken, Dresden 1993
Reproduced in: Morat 1984, p. 8 below

71
Still life, 1956
Pencil, 24 × 33.3 cm
Signed and dated lower right: Morandi 1956
T.159 P.1956 28
Freiburg im Breisgau, Morat-Institut für Kunst und
Kunstwissenschaft
Exhibitions: Saarbrücken, Dresden 1993

72
Still life, 1959
Pencil, 24.2 × 26.6 cm
Signed and dated lower right: Morandi 1959
Not listed in Tavoni
P.1959 17
Private collection
Exhibitions: Saarbrücken, Dresden 1993

73
Still life, 1959
Pencil, 19 × 28.1 cm
Signed and dated lower left: Morandi 1959
T.204 P.1959 16
Private collection
Exhibitions: Munich 1981 – Nijmegen 1982 – Innsbruck
1982 – Saarbrücken, Dresden 1993

74
Still life, 1960
Pencil, 21.9 × 29.9 cm
Signed lower left: Morandi
T.456 A P.1960 19
Gent, Karel Dierickx Collection
Exhibitions: Nijmegen 1982 – Innsbruck 1982 –
Saarbrücken, Dresden 1993 – Münster 1998

75
Still life, 1960
Pencil, 21.9 × 29.9 cm
Signed and dated lower left: Morandi 1960
T.456 P.1960 19
Gent, Karel Dierickx Collection
Exhibitions: Nijmegen 1982 – Innsbruck 1982 –
Saarbrücken, Dresden 1993 – Münster 1998

76
Still life, 1961
Pencil, 24 × 33.3 cm
Signed and dated below centre: Morandi 1961
T.480 P.1961 20
Private collection
Exhibitions: Munich 1981 – Nijmegen 1982 – Innsbruck
1982 – Saarbrücken, Dresden 1993

77
Still life, 1961
Pencil, 22.6 × 15.2 cm
Signed and dated below centre: Morandi 1961
T.478 P.1961 9
Freiburg im Breisgau, Morat-Institut für Kunst und
Kunstwissenschaft
Exhibitions: Munich 1981 – Nijmegen 1982 – Innsbruck
1982 – Saarbrücken, Dresden 1993

78
Landscape, 1962
Pencil, 19.2 × 23.9 cm
Signed lower right: Morandi
Not listed in Tavoni
P.1960 55
Freiburg im Breisbau, Morat-Institut für Kunst und
Kunstwissenschaft
Exhibitions: Saarbrücken, Dresden 1993
Reproduced in: Sydney 1997, p. 19

79
Landscape, 1962
Pencil, 24.3 × 33.3 cm
Signed below centre: Morandi
T.272 P.1962 94
Exhibitions: Saarbrücken, Dresden 1993
Reproduced in: Neri Pozza 1976, pl. 78

80
Still life, 1962
Pencil, 27.3 × 19.1 cm
Signed and dated lower right: Morandi 1962
T.283 P.1962 57
Freiburg im Breisgau, Morat-Institut für Kunst und
Kunstwissenschaft
Exhibitions: Munich 1981 – Nijmegen 1982 – Innsbruck
1982 – Saarbrücken, Dresden 1993
Reproduced in: Morat 1979

81
Still life, 1962
Pencil, 19.3 × 27.2 cm
Signed and dated below centre: Morandi 1962
Not listed in Tavoni
P.1962 68
Private collection
Exhibitions: Saarbrücken, Dresden 1993

82
Still life, 1962
Pencil, 24.2 × 33 cm
Not listed in Tavoni
P.1962 45
Private collection
Exhibitions: Saarbrücken, Dresden 1993
Reproduced in: Morat 1984, p. 20 – Quaderni
Morandiani 1985, p. 110 top

83
Still life, 1962
Pencil, 24.2 × 33 cm
Signed and dated lower left: Morandi 1962
T.287 P.1962 45
Private collection
Exhibitions: Munich 1981 – Nijmegen 1982 – Innsbruck
1982 – Saarbrücken, Dresden 1993
Reproduced in: Morat 1979, p. 47 – Quaderni
Morandiani 1985, p. 110 bottom left

84
Still life, 1963
Pencil, 16.7 × 24.2 cm
Signed lower right: Morandi
Not listed in Tavoni
P.1962 48
Freiburg im Breisgau, Morat-Institut für Kunst und
Kunstwissenschaft
Exhibitions: Saarbrücken, Dresden 1993
Reproduced in: Morat 1984, p. 14 – Quaderni
Morandiani 1985, p. 111 bottom right

85
Still life, 1963
Pencil, 16.8 × 24.1 cm
Signed lower left: Morandi
T.304 P.1963 67
Private collection
Exhibitions: Nijmegen 1982 – Innsbruck 1982 –
Saarbrücken, Dresden 1993

86
Still life, 1962
Pencil, 16.9 × 24.1 cm
Signed below centre: Morandi
Not listed in Tavoni
P.1962 22
Private collection
Exhibitions: Saarbrücken, Dresden 1993

87
Still life, 1962
Pencil, 16.6 × 24.2 cm
Signed and dated lower right: Morandi 1962
T.269 P.1962 18
Private collection
Exhibitions: Munich 1981 – Nijmegen 1982 – Innsbruck
1982 – Saarbrücken, Dresden 1993

88
Still life, 1963
Pencil, 19.3 × 27.4 cm
Signed and dated below centre: Morandi 1963
Not listed in Tavoni
P.1963 44
Private collection
Exhibitions: Saarbrücken, Dresden 1993

89
Still life, 1963
Pencil, 24 × 16.6 cm
Signed lower left: Morandi
T.182 (incorrectly dated as 1958) P.1963 45
Freiburg im Breisgau, Morat-Institut für Kunst und
Kunstwissenschaft
Exhibitions: Ferrara 1978 – Nijmegen 1982 – Innsbruck
1982 – Saarbrücken, Dresden 1993

90
Still life, 1963
Pencil, 20.9 × 30.9 cm
Signed below centre: Morandi
T.293 P.1963 11
Freiburg im Breisgau, Morat-Institut für Kunst und
Kunstwissenschaft
Exhibitions: Nijmegen 1982 – Innsbruck 1982 –
Saarbrücken, Dresden 1993

91
Still life, 1963
Pencil, 18.9 × 27.5 cm
Signed below centre: Morandi
T.292 P.1963 10
Freiburg im Breisgau, Morat-Institut für Kunst und
Kunstwissenschaft
Exhibitions: Nijmegen 1982 – Innsbruck 1982 –
Saarbrücken, Dresden 1993

92
Still life, 1963
Pencil, 16.8 × 24.2 cm
Signed lower left: Morandi
Not listed in Tavoni
P.1963 63
Freiburg im Breisgau, Morat-Institut für Kunst und
Kunstwissenschaft
Exhibitions: Saarbrücken, Dresden 1993

93
Still life, 1963
Pencil, 24.2 × 16.6 cm
Signed lower left: Morandi
T.499 P.1963 60
Private collection
Exhibitions: Munich 1981 – Nijmegen 1982 – Innsbruck
1982 – Saarbrücken, Dresden 1993

Etchings

94
Landscape (House in Grizzana), 1927
Casa a Grizzana
Zinc etching, 26.1 × 20 cm
Second state
Numbered on the edge of the paper lower left:
5/50
Signed and dated lower right: Morandi 927
(in Morandi's sister Dina's handwriting)
V.32 C.1927 3
Freiburg im Breisgau, Morat-Institut für Kunst und
Kunstwissenschaft
Exhibitions: Munich 1981 – London, Glasgow,
Cardiff, Manchester 1991/92 – Saarbrücken,
Dresden 1993

95
Hilly landscape, 1927
Paesaggio del Poggio
Copperplate etching, 23.4 × 29 cm
Second state
Numbered lower left: 15/50
Signed and dated lower right: Morandi 1927
V.33 C.1927 4
Freiburg im Breisgau, Morat-Institut für Kunst und
Kunstwissenschaft
Exhibitions: Munich 1981 – London, Glasgow,
Cardiff, Manchester 1991/92 – Saarbrücken,
Dresden 1993

96
Still life with small cup and carafe, 1929
Natura morta con tazzina e caraffa
Zinc etching, 25.8 × 29.2 cm
Unique state, printed on China paper pressed
onto heavier paper
Numbered lower left: 20/40
Signed lower right: Morandi
V.56 C.1929 4
Freiburg im Breisgau, Morat-Institut für Kunst und
Kunstwissenschaft
Exhibitions: Munich 1981 – London, Glasgow,
Cardiff, Manchester 1991/92 – Saarbrücken,
Dresden 1993

97
Still life with small white cup on the left, 1930
Natura morta con la tazzina bianca a sinistra
Copperplate etching, 18.7 × 28.6 cm
Second state
Numbered lower left: 6/30
Signed lower right: Morandi
V.70 C.1930 3
Freiburg im Breisgau, Morat-Institut für Kunst und
Kunstwissenschaft
Exhibitions: Munich 1981 – London, Glasgow,
Cardiff, Manchester 1991/92 – Saarbrücken,
Dresden 1993

98
Still life with drapery on the left, 1927
Natura morta con il panneggio a sinistra
Zinc etching, 24.9 × 35.8 cm
Second state
Numbered lower left: 37/40
Signed and dated lower right: Morandi 1927
V.31 C.1927 2
Private collection
Exhibitions: Munich 1981 – London, Glasgow,
Cardiff, Manchester 1991/92 – Saarbrücken,
Dresden 1993

99
Large still life with petroleum lamp, 1930
Grande natura morta con la lampada a petrolio
Copperplate etching, 30.5 × 36.2 cm
Fifth state
Numbered lower left: 26/40
Signed lower right: Morandi
V.75 C.1930 8
Private collection
Exhibitions: Munich 1981 – London, Glasgow,
Cardiff, Manchester 1991/92 – Saarbrücken,
Dresden 1993

100
Still life with vases on a table, 1931
Natura morta di vasi su un tavolo
Copperplate etching, 24.9 × 33.6 cm
Unique state
Four unnumbered and unsigned impressions
V.84 C.1931 5
Private collection
Exhibitions: Munich 1981 – London, Glasgow,
Cardiff, Manchester 1991/92 – Saarbrücken,
Dresden 1993

101
Still life with bold lines, 1931
Natura morta a grandi segni
Zinc etching, 24.7 × 34.4 cm
Second state
Numbered lower right: 30/50
Signed and dated lower left: Morandi 1931
V.83 C.1931 4
Private collection
Exhibitions: Munich 1981 – London, Glasgow,
Cardiff, Manchester 1991/92 – Saarbrücken,
Dresden 1993

102
Still life with drapery, 1931
Natura morta con il panneggio
Copperplate etching, 24.8 × 31.5 cm
Unique state
Numbered lower left: 4/40
Signed and dated lower right: Morandi 1931
V.80 C.1931 1
London, private collection
Exhibitions: Munich 1981 – London, Glasgow,
Cardiff, Manchester 1991/92 – Saarbrücken,
Dresden 1993

103
Still life (Various objects on a table), 1931
Vari oggetti su un tavolo
Copperplate etching, 17.5 × 19.4 cm
Unique state, printed on China paper pressed
onto heavier paper
Edition of 30 impressions
Inscribed lower left: p.1 (first artist's proof)
Signed lower right: Morandi
V.87 C.1931 7
Freiburg im Breisgau, Morat-Institut für Kunst und
Kunstwissenschaft
Exhibitions: Munich 1981 – London, Glasgow,
Cardiff, Manchester 1991/92 – Saarbrücken,
Dresden 1993

104
Landscape, c. 1930
Copperplate etching, 17.5 × 19.4 cm
Unique state
Numbered lower left: 33/50
Signed lower right: Morandi
V.77 C.1930 13
Private collection
Exhibitions: Munich 1981 – London, Glasgow,
Cardiff, Manchester 1991/92 – Saarbrücken,
Dresden 1993

105
Landscape (View of "della Montagnola" Park
in Bologna), 1932
Veduta della Montagnola di Bologna
Copperplate etching, 20.8 × 33.2 cm
Unique state
Numbered lower left: 34/50
Signed lower right: Morandi
V.93 C.1932 3
Freiburg im Breisgau, Morat-Institut für Kunst und
Kunstwissenschaft
Exhibitions: Munich 1981 – London, Glasgow,
Cardiff, Manchester 1991/92 – Saarbrücken,
Dresden 1993

106
Still life with nine objects, 1954
Natura morta con nove oggetti
Copperplate etching, 18 × 25 cm
Unique state
Numbered lower left: 21/100
Signed and dated lower right: Morandi 1954
V.115 C.1954 1
Private collection
Exhibitions: Munich 1981 – London, Glasgow,
Cardiff, Manchester 1991/92 – Saarbrücken,
Dresden 1993

107
Still life with five objects, 1956
Natura morta con cinque oggetti
Copperplate etching, 14 × 19.9 cm
Third state
Unnumbered: edition of 165 impressions
Signed lower left: Morandi; dated lower right:
1956
V.116 C.1956 1
Private collection
Exhibitions: London, Glasgow, Cardiff, Manchester
1991/92 – Saarbrücken, Dresden 1993

108
Still life with four objects and three bottles,
1956
Natura morta con quattro oggetti e tre bottiglie
Copperplate etching, 20.3 × 19.9 cm
Second state
Numbered lower left: 75/100
Signed and dated lower right: Morandi 1956
V.117 C.1956 2
Private collection
Exhibitions: Munich 1981 – London, Glasgow,
Cardiff, Manchester 1991/92 – Saarbrücken,
Dresden 1993

109
Small still life with three objects, 1961
Piccola natura morta con tre oggetti
Copperplate etching, 12.3 × 15.7 cm
(reproduced here in original size)
Unique state
Numbered lower left: 5/100
Signed lower right: Morandi
V.131 C.1961 1
Freiburg im Breisgau, Morat-Institut für Kunst und
Kunstwissenschaft
Exhibitions: Munich 1981 – London, Glasgow, Cardiff,
Manchester 1991/92 – Saarbrücken, Dresden 1993

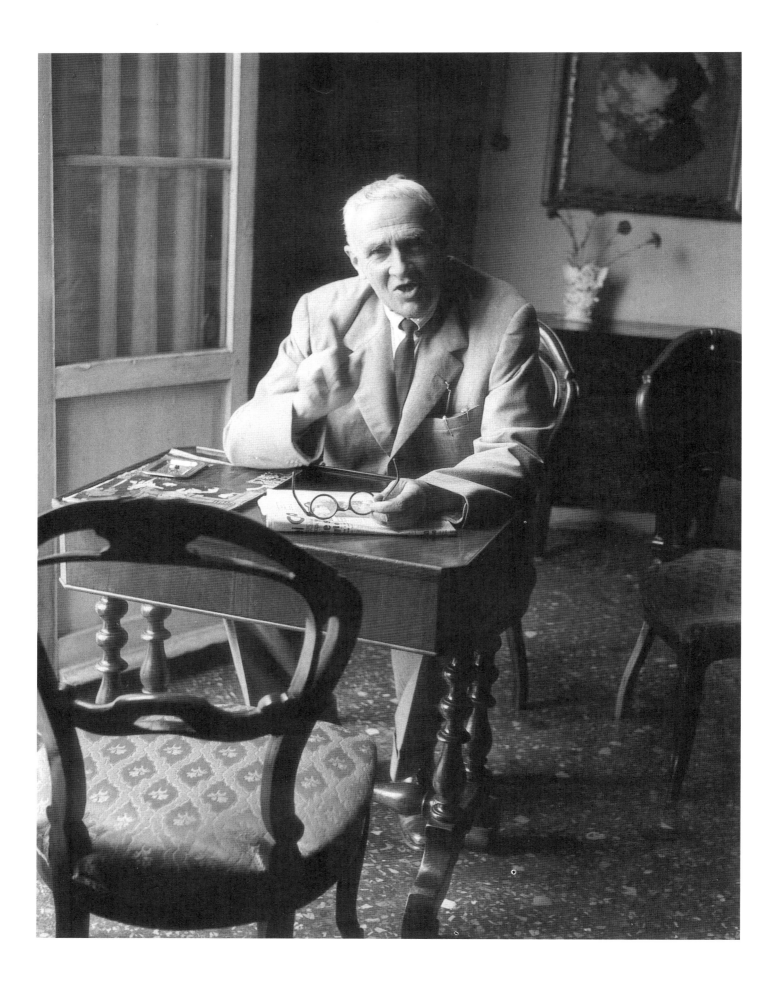

Biography

Giorgio Morandi was born on 20 July 1890 in Bologna, Italy, as the eldest son of Andrea Morandi and Maria Macca-

ferri. His brother Giuseppe, who was two years younger, died in 1903, and Giorgio lived together with his sisters, Anna (1895–1989), Dina (1900–1977) and Maria Teresa (1906–1994), all his life. The house where he was born in Via delle Lame 57 no longer exists. However, the new house built on the site, has had a commemorative plaque on the façade since 1966.

After his father's death in 1910, Morandi moved to a flat in Via Fondazza 36 with his mother and sisters, where he lived for more than 50 years until his death on 18 July 1964. His studio has been kept exactly as the painter left it.

After spending a year working in the office of his father's commercial enterprise, Morandi began his studies at the Accademia di Belle Arti in Bologna in 1907.

Giorgio Morandi in his flat in Via Fondazza, 1959

During his days as a student, which continued until 1913, he made several excursions: in 1909 and 1910 to the

The Morandi family in 1902. From left to right: his brother Giuseppe, his father with his sister Dina on his knee, Giorgio, his mother and his sister Anna

Giorgio Morandi, around 1907–08

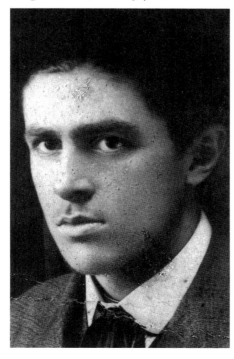

VIIIth and IXth Biennale in Venice; in 1910 to Florence, where he marvelled at the works of Giotto, Masaccio and Paolo Uccello; and on the occasion of the "International Exhibition" in Rome, where he saw several of Claude Monet's

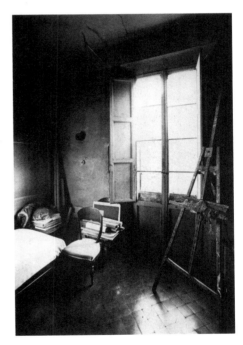

In the studio in Via Fondazza in Bologna

paintings. He was first introduced to the works of Paul Cézanne in 1909 through reproductions in the book by Vittorio Pica, *Gl'impressionisti francesi*, that had been published a year earlier in Bergamo (Istituto d'Arti Grafiche).

In 1913 Morandi went to Grizzana for the first time. This mountain village, 35 km west of Bologna and some 800 metres above sea level in the Apennines, became his second home. The municipality was re-named "Grizzana Morandi"

159

The Galleria Sprovieri in Rome staged the "First Independent Futurist Exhibition" from 13 April to 15 May, in which Morandi participated; shortly afterwards he was represented again in the "Second Secession Exhibition," where watercolours by Cézanne and paintings by Henri Matisse were also shown. From Rome, Morandi travelled to Assisi to study Giotto's frescoes, and in the autumn he went to Padua with Bacchelli to see the Arena Chapel.

Shortly after Morandi was drafted in 1915 to join the 2nd grenadier regiment in Parma, he became seriously ill and

Portrait of Riccardo Bacchelli by Giorgio Morandi. Frontispiece of La Ruota del Tempo, *Bologna 1928*

in 1990 to celebrate the one hundredth anniversary of the artist's birth.

In late 1913 Morandi met the writer Riccardo Bacchelli, who became one of his closest friends.

Early in 1914 Morandi visited an exhibition of Futurist painting in Florence. On 20 January, while attending a Futurist evening performance at the Teatro del Corso in Bologna, he met Umberto Boccioni and Carlo Carrà.

Grizzana

*The front door of
Morandi's flat in Via
Fondazza in Bologna*

can definitely be classified as reflecting
the style of this movement (v.34–40 and
44), all of which were painted between
spring 1918 and autumn 1919. Four of
them show the head of the "Manichi-
no," the marionette that was the trade-
mark of 'Pittura metafisica.' It was after
this period, at the end of 1919, that
Morandi first met de Chirico, in Rome.
Considering Morandi's oeuvre as a
whole, his 'metaphysical' works merely
represent a marginal phase.

In 1920 Morandi made his third
visit to the Biennale in Venice where,
in the French pavilion, he saw 28 oil
paintings by Cézanne for the first time.

In the Kronprinzenpalais in Berlin,
Mario Broglio organised an exhibition

was dismissed as unfit for military ser-
vice six weeks later.

On 15 November 1918 the first issue
of the journal founded by Mario Broglio,
Valori Plastici, was published in Rome.
Essentially the organ of the "Pittura
metafisica" movement, this annual
publication only appeared three times.
Carrà and Giorgio de Chirico played a
major role in this publication – not only
as painters, but also as writers. The fact
that Morandi's works were also well
represented (with 15 reproductions in
total) later led to his being categorised in
numerous encyclopedias and collections
as one of the three protagonists of "Pit-
tura metafisica." This is misleading, as
there are really only eight paintings that

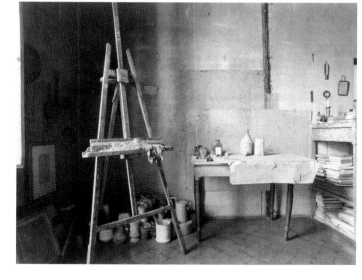

*Right and below:
In the studio in Via
Fondazza in Bologna*

in March 1921, to which Carrà, De Chi-
rico and Morandi all contributed works.
In Paul Westheim's "Kunstblatt" (vol-
ume 5, Berlin 1921, pp. 51–52), Theodor
Däubler wrote about Morandi in his
review of the "Modern Italian Paint-
ers": "The creations by the Bolognese
painter Giorgio Morandi are quite
severe: he is thus very closely allied to
both a common classical ideal and a
rigorously modern approach; for the
time being, he is showing us almost
nothing but still lifes in the most re-
fined nuances of colour. It is mysterious
and surprising to observe how he suc-
ceeds in transforming a play of yellow
with golden accents into a silvery atmos-
phere. For van Gogh, yellow was a

dramatic element; for Morandi, delicate yellowish hues lisp gentle lyrics, despite the severity. He grasps the geometrical element that has been evident since Cézanne, in a powerful and often vivid manner. The simplest of forms: cylinders roll, cubes sit clearly on a surface, yet all the while what is actually present is never lost; jugs, bowls, bottles are cosmic realities in art such as this: vases are sculptural collections of feminine charms; a few closely bunched flowers recall the starry delights among mortals."

The twenties as a whole were characterised by considerable financial difficulties. After having received his diploma from the Academy and taken a job as a drawing teacher in Bologna back in 1914, Morandi had to increase

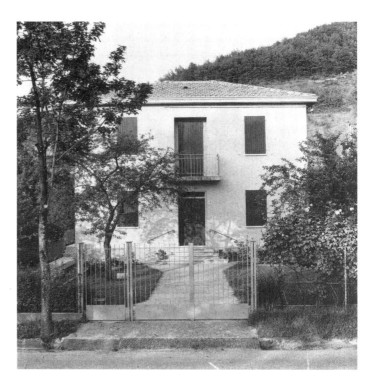

Morandi's country house in Grizzana

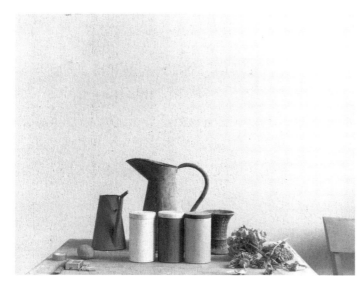

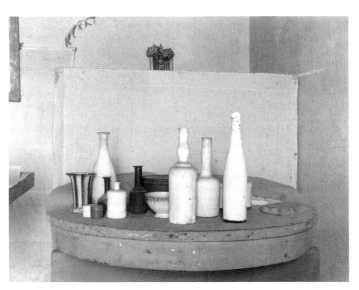

In Morandi's studio in Grizzana

his school activities by working for several small communities in the provinces of Reggio Emilia and Modena as a school inspector. The situation improved in 1930 when he received a teaching position for etching techniques (tecnica dell'incisione) at the Bologna Academy. Financial security and independence, while devoting as little time to teaching commitments as possible, were important prerequisites for Morandi as he strove to develop his artistic concepts without undue distraction. Morandi's mature artistic style was reached in the early 1940s, at which time he also increased his output, only to be restricted one more time, due to the war, between 1944 and 1945.

Left and right: In the studio in Bologna

From 1927 to 1932 Morandi spent every summer in Grizzana and, from 1933 to 1938, in the neighbouring village of Roffeno. He spent the war years almost entirely in Grizzana, which led to an increase in the number of his landscape pictures. In 1933 Morandi moved to new quarters in the house in Via Fondazza and, in 1935, he acquired the studio that he used for the rest of his

life. While the first flat had faced the street, the windows of the studio were open to the courtyard; for this reason, it was not until 1935 that views of the "Cortile di Via Fondazza" appeared in his works. He continued painting this view until 1960, when new construction forced Morandi to stop landscape painting from the window of his studio. As a result he spent most of the last four years of his life in Grizzana, where since the spring of 1960 he had a country

Giorgio Morandi and Dino Prandi in Grizzana on 7 July 1963

heim, fitting in a visit to the Robert von Hirsch collection and the Kunstmuseum.

At the IVth Biennale in São Paulo in 1957 Morandi was awarded the First Prize for Painting, after having won the First Prize for Graphic Art there for his etchings back in 1953. At the first "documenta" in Kassel in 1955 Werner Haftmann set up a cabinet with eleven pictures by Morandi and, in 1962, the German city of Siegen awarded him the Rubens Prize. Despite his increasing fame, Morandi greatly prized his privacy and stubbornly turned down major

retreat of his own. This also explains the high proportion of landscapes among his late works, whereas in the years from 1945 to 1959 this genre had played a very minor role.

At the end of June in 1956, after officially retiring, Morandi made his first and only trip abroad in his life. He attended the opening of an exhibition organised by Heinz Keller at the Kunstverein Winterthur in Switzerland in honour of both himself and Giacomo Manzù. He also visited the Oskar Reinhart collection near Römerholz and the Kunsthaus in Zurich before travelling on to Basel to his friend Georges Floers-

Morandi and Elena Chiesa, 1963

Below: Giorgio Morandi in the sixties

Giorgio Morandi, 1963

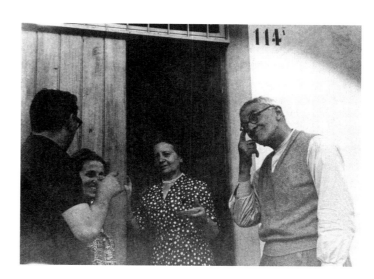

*Giorgio Morandi
(right) and his sister
Anna (centre) with
guests in Grizzana*

*Giorgio Morandi in
the sixties*

exhibition projects. As a consequence
there were no large exhibitions until
after his death: 1965 in Berne, 1966 in
Bologna and 1973 in Rome.

Morandi's last work is signed Feb-
ruary 1964. Following a long illness
Morandi died on 18 June 1964 in his flat
in Via Fondazza. Giacomo Manzù sculp-
ted the portrait bust for Morandi's grave
in La Certosa cemetery in Bologna.
In the autumn of 1993, the Museo
Morandi was opened. The collection
of 200 works (61 paintings, 13 water-
colours, 42 drawings and 84 etchings)
is housed in the Palazzo d'Accursio in
Bologna, the ancient seat of the muni-
cipal government of his native city.

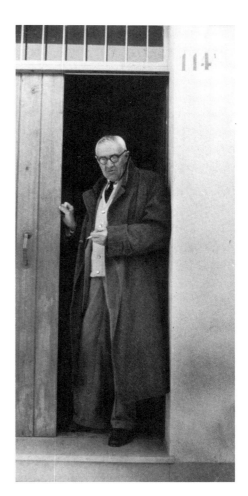

*One of the last photos of Giorgio Morandi at
the door of his house in Grizzana*

165

Selected Bibliography

The abbreviations C., P., T. and V. refer to the authors of the oeuvres catalogues.

Oeuvres Catalogues

1. Paintings

Lamberto Vitali, *Morandi, Catalogo Generale*, vol. 1: *1910–1947*,
vol. 2: *1948–1964*, Milan 1977
The two volumes list 1345 paintings. The second edition from 1983 contains 31 additional paintings; since then no more than 20 more paintings appeared, so that the entire number of oil paintings is not more than 1,400.

2. Watercolours

Marilena Pasquali, *Morandi, Acquerelli, Catalogo Generale*, Milan 1991
This catalogue lists 259 watercolours; it is not as complete as the catalogue of paintings, but the total number should not be more than 300.

3. Drawings

Efrem Tavoni, *Morandi, Disegni*, vol. 1: nos. 1- 318, vol. 2: nos. 319– 506, Sasso Marconi 1981 and 1984

Marilena Pasquali, *Morandi, Disegni, Catalogo Generale*, Milan 1994
This catalogue contains 780 pieces, ca. 90 % of all his drawings.

4. Etchings

Lamberto Vitali, *Morandi, Opera Grafica*, Turin 1957
117 facsimile prints in slipcase (all pieces reproduced in original size).
Morandi had only three titles for his works: still life, landscape, flowers. More elaborate titles concerning the prints come from Lamberto Vitali, but were approved by Morandi.

Lamberto Vitali, *L'opera grafica di Giorgio Morandi* (Pocket book from the "Saggi" series, vol. 350), Turin, 1st edition 1964 (131 plates), 2nd edition 1978 (132 plates), 3rd edition 1989 (137 plates)
Michele Cordaro, *Morandi, Incisioni, Catalogo Generale*, Milano 1991
77 of the etchings described here have appeared in series of usually 30, 40, or 50 prints.

Monographs

Francesco Arcangeli, *Giorgio Morandi*, Milan, 1st edition 1964, 2nd edition 1968 (Pocketbook in the "Saggi" series, vol. 629), Turin 1981

Basile 1982
Franco Basile, *Il laboratorio della solitudine*, Sasso Marconi 1982
Cesare Brandi, *Morandi*, Rome 1990
This volume is a compilation of all contributions by Brandi between 1942 and 1984. In addition, it contains the correspondence between Brandi and Morandi from 1938 to 1963.

Angelika Burger, *Die Stilleben des Giorgio Morandi*, Hildesheim 1984

Giuffré 1970
Guido Giuffré, *Giorgio Morandi*, Luzern 1970

Walter Hertzsch, *Giorgio Morandi*, Leipzig 1979

Jouvet/Schmied 1982
Jean Jouvet und Wieland Schmied, *Giorgio Morandi – Ölbilder, Aquarelle, Zeichnungen, Radierungen*. Zurich 1982

Luigi Magnani, *Il mio Morandi* (Pocketbook from the "Saggi" series, vol. 646, Turin 1982

Morat 1979
Franz A. Morat, *Giorgio Morandi, Ölbilder, Aquarelle, Zeichnungen, Radierungen*, Freiburg im Breisgau 1979

Morat 1984
Franz A. Morat (ed.), *Giorgio Morandi, Seine Werke im Morat-Institut für Kunst und Kunstwissenschaft*, Freiburg im Breisgau 1984
Texts by Cesare Brandi, Giovanni Testori and Franz Armin Morat.

Neri Pozza 1976
Neri Pozza, *Morandi, I disegni*, Rome 1976

Pasini 1989
Pasini, *Morandi*, Bologna 1989
Quaderni Morandiani 1985
Morandi e il suo tempo, I Incontro internazionale di studi su Giorgio Morandi, Quaderni Morandiani, no. 1, Milan 1985

Ragghianti 1982
Carlo L. Ragghianti, *Bologna cruciale 1914 e saggi su Morandi, Gorni, Saetti*, Bologna 1982

Giuseppe Raimondi, *Anni Con Giorgio Morandi*, 1970.

Strauss 1983
Ernst Strauss, *Koloritgeschichtliche Untersuchungen zur Malerei seit Giotto und andere Studien*, Munich 1983

Vitali 1964, 1965², 1970³
Lamberto Vitali, *Giorgio Morandi Pittore*, Mailand, 1st edition 1964, 2nd edition 1965, 3rd edition 1970

Exhibition Catalogues

Bern 1965
Giorgio Morandi – Retrospektive, Kunsthalle Bern, 23 October–5 December 1965
Text by Werner Haftmann.

Bologna 1966
Giorgio Morandi – Retrospektive, Palazzo dell'Archiginnasio, Bologna, 30 October–15 December 1966
Texts by Lamberto Vitali and Riccardo Bacchelli.

Venice 1966
Giorgio Morandi, XXXIII Esposizione Biennale Internazionale d'Arte, Venice, 18 June–16 October 1966
Text by Roberto Longhi.

Geneva 1968
Giorgio Morandi, Galerie Krugier,
October–November 1968

Milan 1971
Giorgio Morandi – Retrospektive, Rotonda
della Besana, Milan, May–June 1971
Texts by Francesco Arcangeli, Jean Leymarie
and Andrew Forge.

St. Petersburg/Moscow 1973
Giorgio Morandi – Retrospektive, Ermita-
ge, Leningrad (St. Petersburg), 17 April–
10 May 1973; Puschkin-Museum, Moscow,
May–June 1973

Rome 1973
Giorgio Morandi – Retrospektive, Galleria
Nazionale d'Arte Moderna, Rome,
18 May–22 July 1973
Texts by Cesare Brandi and Giorgio de Marchis.

Geneva 1977/78
Giorgio Morandi, Galerie Jeanneret,
Geneva, November 1977–January 1978

Ferrara 1978
Giorgio Morandi – Retrospektive, Palazzo
dei Diamanti, Galleria Civica d'Arte
Moderna, Ferrara, July–October 1978
Text by Franco Solmi.

Frankfurt am Main 1978
Giorgio Morandi, Westend Galerie, Frank-
furt am Main, September–October 1978

Geneva 1978/79
Giorgio Morandi, Galerie Jeanneret,
Geneva, November 1978–January 1979

Munich 1981
*Giorgio Morandi, Ölbilder, Aquarelle,
Zeichnungen, Radierungen*, Haus der
Kunst, Munich, 18 July–6 September 1981
Texts by Franz Armin Morat, Ernst Strauss,
Lorenz Dittmann, Gottfried Boehm, Bernd
Growe, Raimer Jochims, Charles Wentinck and
Amy Namowitz Worthen.

San Francisco, New York, Des Moines
1981/82
Giorgio Morandi, San Francisco Museum
of Modern Art, 24 September–1 Novem-
ber 1981; The Solomon R. Guggenheim
Museum, New York, 19 November 1981–
17 January 1982; Des Moines Art Center,
1 February–14 March 1982
Texts by James T. Demetrion, Luigi Magnani,
Joan M. Lukach, Kenneth Baker and Amy Namo-
witz Worthen.

Nijmegen/Innsbruck 1982
*Morandi. Die Sammlung des Morat-Insti-
tuts für Kunst und Kunstwissenschaft*, Nij-
meegs Museum – Commanderie van St.
Jan, April–May 1982; Tiroler Künstler-
schaft im Kunstpavillon im Kleinen Hof-
garten, Innsbruck, May–Juni 1982
Text by Hans van der Grinten.

Madrid 1984/85
Giorgio Morandi 1890 –1964, Fundacion
Caja De Pensiones, Madrid, 11 December
1984–28 January 1985
Texts by Cesare Brandi, Carlo Bertelli and Julian
Gallego.

Marseille 1985
Giorgio Morandi 1890 –1964, Musée Can-
tini, Marseille, 13 April–18 June 1985
Texts by Carlo Bertelli, Claude Esteban and Ces-
are Brandi.

Tübingen/Düsseldorf 1989/90
*Giorgio Morandi, Gemälde, Aquarelle,
Zeichnungen, Radierungen*, Kunsthalle
Tübingen, 23 September–26 November
1989; Kunstsammlung Nordrhein-Westfa-
len, Düsseldorf, 20 January–18 March 1990
Texts by Werner Haftmann, Pier Giovanni Casta-
gnoli, Marilena Pasquali, Flaminio Gualdoni,
Giuliano Briganti, Michael Semff and Fabrizio
D'Amico.

Bologna 1990
*Giorgio Morandi 1890 –1990, Mostra del
Centenario*, Bologna, Galleria comunale
d'arte moderna "Giorgio Morandi",
12 May–2 September 1990
Texts by Marilena Pasquali, Werner Haftmann,
Pier Giovanni Castagnoli, Flaminio Gualdoni,
Michael Semff and Fabrizio D'Amico.

Bologna 1990/91
Morandi, Gli acquerelli, Bologna, Galleria
comunale d'arte moderna "Giorgio
Morandi", 15 December 1990–
10 February 1991
Texts by Marilena Pasquali and Umberto Eco.

London, Glasgow, Cardiff, Manchester
1991/92
Giorgio Morandi, Etchings, Tate Gallery,
London, 20 November 1991–9 February
1992; Kelvingrove Art Gallery, Glasgow,
15 February–29 March 1992; National
Museum of Wales, Cardiff, 4 April–
17 May 1992; Manchester City Art Gallery,
23 May–5 Juli 1922
Texts by Jennifer Mundy and Christopher Le
Brun.

Brussels 1992
Giorgio Morandi artista d'Europa, Brüssel,
Le Botanique, 12 June–9 August 1992
Texts by Marilena Pasquali, Roberto Tassi, Mari-
anne R. Bourge and Vanni Scheiwiller.

Saarbrücken/Dresden 1993
*Giorgio Morandi – Gemälde, Aquarelle,
Zeichnungen, Radierungen*, Saarland
Museum, Saarbrücken, 31 January–
21 March 1993, Gemäldegalerie Neue
Meister und Kupferstich-Kabinett, Dres-
den, 4 April–6 June 1993
Ernst-Gerhard Güse and Franz Armin Morat
(Eds.)
Texts by Gottfried Boehm, Lorenz
Dittmann, Ernst-Gerhard Güse
This exhibition was also shown in Eger, Bohemia
(Cheb), Salzburg (Rupertinum) and Frankfurt am
Main (Jahrhunderthalle Hoechst).
The book is a catalogue of the collection of the
Morat-Institut für Kunst und Kunstwissenschaft
in Freiburg im Breisgau.

Milan 1993
Museo Morandi Bologna
il Catalogo (Edition Charta) Milan 1993
[Catalogue of the museum for its opening on
4 October 1993]

Vienna/Rotterdam 1995
*Giorgio Morandi. Die Aquarelle,
De Aquarellen*
Albertina, Vienna, 7 March to 17 April
1995, Kunsthal, Rotterdam, 13 May–
2 July 1995
Marilena Pasquali (Ed).

Klagenfurt/Ljubljana 1996/97
*Giorgio Morandi. Expressive Ausdrucks-
formen*, Stadtgalerie, Klagenfurt,
20 December 1996–9 February 1997,
Cankarjev Cathedral, Ljubljana,
14 February–31 March 1997
Marilena Pasquali (Ed.)

Paris 1996/97
Giorgio Morandi. Rétrospective
Fondation Dina Vierny-Musée Maillol
and Union Latine, 6 December 1996–
15 February 1997
Texts by Jean Clair, Paolo Fossati and Michaela
Scolaro.

Sydney 1997
*Giorgio Morandi the dimension of
inner space*, Art Gallery of New South
Wales, Sydney, 9 Mai–13 July 1997
by Lou Klebac
with texts by Marilena Pasquali, Josef Herman,
Pompilio Mandelli and Luigi Ficacci.

Rolandseck 1997/98
*Giorgio Morandi: Gemälde, Aquarelle,
Zeichnungen, Radierungen*, Behrthof
Rolandseck, 31 October 1997–
11 January 1998
Texts by Franz Armin Morat, Werner Haftmann,
John Berger, Roberto Longhi, Wayne Thiebaud,
Gunda Luyken and Siegfried Gohr.

Verona/Venice 1997/98
Morandi ultimo – nature morte 1950–1964,
Galleria dello Scudo, Verona, 14 December
1997–28 February 1998, Collezione Peggy
Guggenheim, Venice, 30 April–13 Sep-
tember 1998
Laura Mattioli Rossi (Ed.)
Texts by Laura Mattioli Rossi, Fausto Petrella,
Franz Armin Morat, Giuseppe Panze di Biumo
and others
English edition of the catalogue:
The Later Morandi – Still Lifes 1950 to 1964

Münster 1998
Giorgio Morandi, Galerie Hachmeister,
Münster, 24 April–27 June 1998
with the Sammlung Lohmann Hofmann
Heiner Hachmeister (Ed.)
Text by Castor Seibel.

Schleswig 1998
Giorgio Morandi 1890–1964
Gemälde, Aquarelle, Zeichnungen
Das Druckgraphische Werk, Schleswig-
Holsteinischen Landesmuseums Schloß
Gottorf, Schleswig, 25 Juli–27 September
1998
Texts by Heinz Spielmann, Claudia Gian Ferrari
and Michela Scolaro.

Photographic Credits

Material for the illustrations has been
kindly lent by the authors, collections or
archives acknowledged in the picture cap-
tions, as well by the following:

Walter Breveglieri: p. 164 bottom r.
Ursual Edelmann, Frankfurt: ill. p. 58
Paolo Ferrari: pp. 159 r.; 160 top
Luigi Ghirri: pp. 161 (4); 162 left and right
Giorgio Morandi, *Gemälde, Aquarelle.
 Zeichnungen, Radierungen*, Cologne:
 DuMont 1989: p. 10, ill. 1;
 p. 11, ill. 3; p. 131, ill. 1
Giorgio Morandi, *Ölbilder, Aquarelle,
 Zeichnungen, Radierungen*, Exhib. cat.
 Haus der Kunst, Munich 1981: p. 11,
 ill. 4; p. 15, ill. 5; p. 16, ills. 7, 8
Antonio Guerra, Bologna: p. 49
Peter Heman, Basel: p. 56
Franz Hubmann, Vienna: pp. 158;
 164 bottom l.
Herbert List: Frontispiece
Marilena Pasquali, *Morandi, Acquerelli,
 Catalogo Generale*, Milan 1991:
 p. 71, ills. 1, 2; p. 73, ills. 3, 4
Paolo Prandi, Reggio Emilia: p. 164 top
Renzo Renzi, *La Città di Morandi*,
 Bologna 1989: pp. 160 bottom r.;
 162 top r.; 164 centre; 165 top l. and r.
Hartmut Schmidt, Freiburg i. Br.:
 Plates 8, 13, 19, 26, 36, 41, 46
Pierre Schneider, Matisse, Munich 1984:
 p. 19, ill. 10
Nic Tenwiggenhorn, Düsseldorf:
 ills. pp. 38, 42, 44, 52, 60, 66;
 Plates 18, 22, 24, 30